THE ULTIMATE GUIDE TO CREATING COMICS

WILLIAM POTTER AND JUAN CALLE

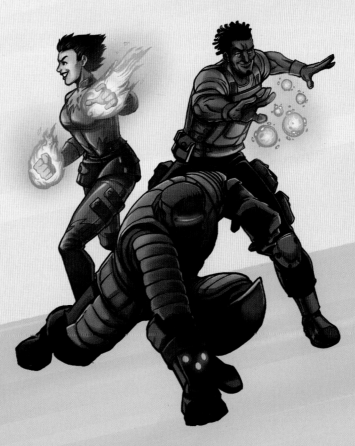

ARCTURUS

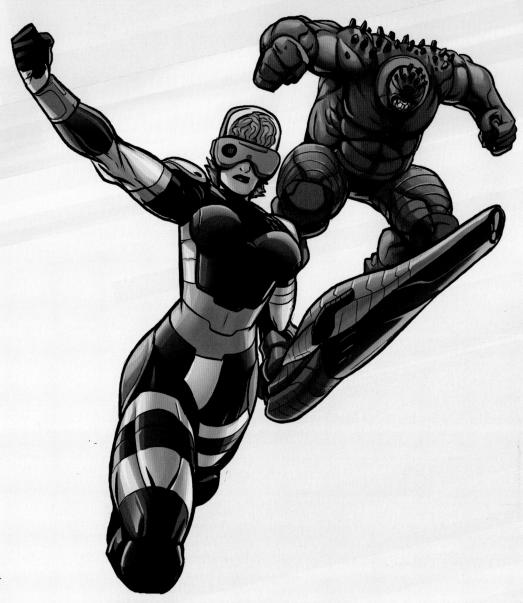

ARCTURUS

This edition published in 2024 by Arcturus Publishing Limited
26/27 Bickels Yard, 151–153 Bermondsey Street,
London SE1 3HA

Copyright © Arcturus Holdings Limited

All rights reserved. No part of this publication may be reproduced, stored in a retrieval system, or
transmitted, in any form or by any means, electronic, mechanical, photocopying, recording, or
otherwise, without prior written permission in accordance with the provisions of the Copyright
Act 1956 (as amended). Any person or persons who do any unauthorized act in relation to this
publication may be liable to criminal prosecution and civil claims for damages.

Text: William Potter
Illustrations: Liberum Donum (Juan Calle)
Colour art: Liberum Donum (Juan Calle and Luis Suarez)
Design: Neal Cobourne
Editor: Joe Harris

ISBN: 978-1-3988-3916-8
CH005157US
Supplier 29, Date 1123, PI00005895

Printed in China

CONTENTS

LET'S MAKE COMICS!

Comics are a fantastic way of sharing stories. Whether your tales are personal or packed with super-powered heroes and villains, we'll help you bring your wildest adventures to life.

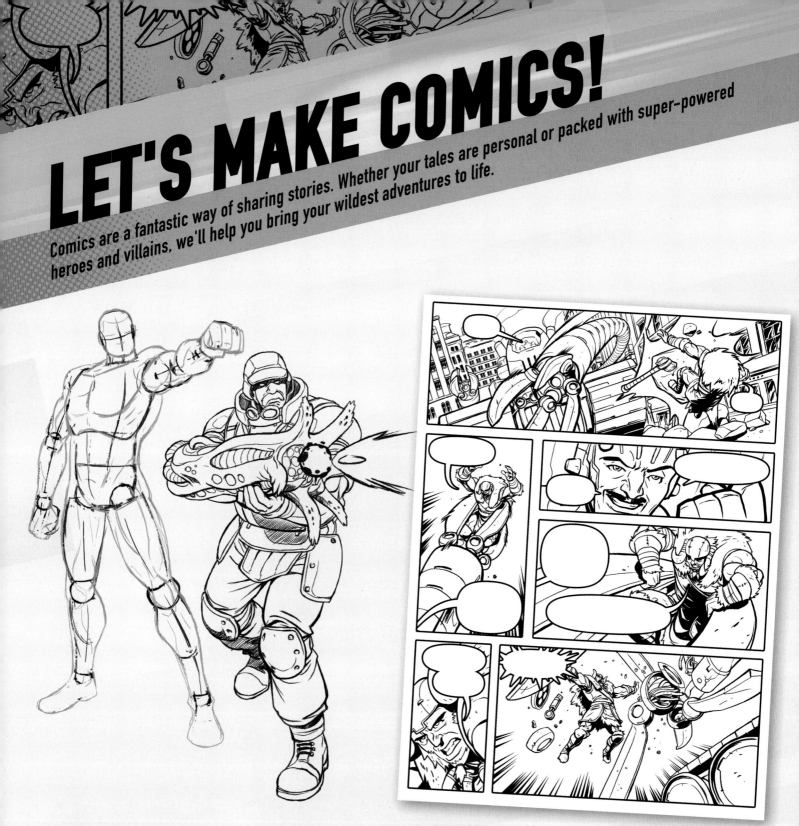

HEROES AND VILLAINS

Whether you want to draw comics just for fun or dream of becoming a comic book professional, this book is packed with ideas and guides to help you. We hope to inspire you to make up your own heroes and villains for incredible adventures. We'll show you the basics for bringing your characters to life and how to put them into a comic strip for all to see.

STEPS AHEAD

From super-powered champions to ruthless villains, step-by-step instructions will show you how to draw convincing characters, with guides on anatomy, poses, costumes, and planning fight scenes.

We'll lead you through the steps to completing your first comic book pages, from story and character design to layouts, penciling, inking, and coloring.

DISCOVER NEW WORLDS

You'll voyage to outer space to craft cosmic adventures in alien worlds with robots and star-spanning spaceships, and into the realm of magic, with warring wizards. You'll discover how to design monstrous characters of rock, wood, and metal and place them in eerie, shadowy scenes.

NO HOLDING BACK!

You don't have to be an amazing artist to tell a riveting tale, but by drawing a little each day, you're sure to improve. Write and draw what you'd like to read, whether it's superhero action, sci-fi, monster stories, or something more down-to-earth. Then, share it with the world! But don't let us slow you down—grab a pencil and start creating comics today!

GETTING STARTED

You don't need a desk full of expensive tools to start making comics. You just need a pen, some paper, and a wild imagination!

PENCILS

Pencils come in various hardnesses—H for hard, B for soft. A 2H pencil is good for making light marks that don't smudge, and a 2B is good for sketching. Try different hardnesses to find those you're most comfortable with. You could also use a mechanical pencil. And you'll need a sharpener and an eraser, of course!

CURVES

Drawing smooth curves for action lines and speech balloons can be tricky. A set of curves or a circle and ellipse template can help. For circles, use a template or compass.

PAPER

Any paper will do for drawing on, especially for early sketches and planning. For the finished comic art, professional comic artists prefer a thick, smooth art paper. Pages are drawn larger than they are printed.

PENS

Pens are a personal choice and artists may try out many before they find the perfect match. You'll need pens that give you a solid, permanent line. When you get into drawing comics, you'll want to have more than one pen to draw different line thicknesses, including a marker pen for filling in large areas.

BRUSHES, FOUNTAIN PENS

Inking over your pencils with a fountain pen or a brush dipped in ink will require some practice and a steady hand, but it can produce great results. A brush will give you more control over the thickness of your lines and is good for filling in large areas with a black that won't fade. Brush pens, available from art stores, are also worth trying.

STRAIGHT EDGES

You'll need a smooth metal or plastic ruler to draw comic panels and lines for comic book lettering. A triangle is also useful for panel drawing.

Of course, a lot of artists have moved on to drawing and coloring comics using tablets and computers, but for starting out and practicing the skills that could lead to a professional comic book career, nothing beats good old pen and paper for getting your ideas down.

BODY MATTERS

When you know the right proportions and where the muscles, knees, and elbows go, your characters will look much more believable. Here you can see an average male and female body and their relative proportions.

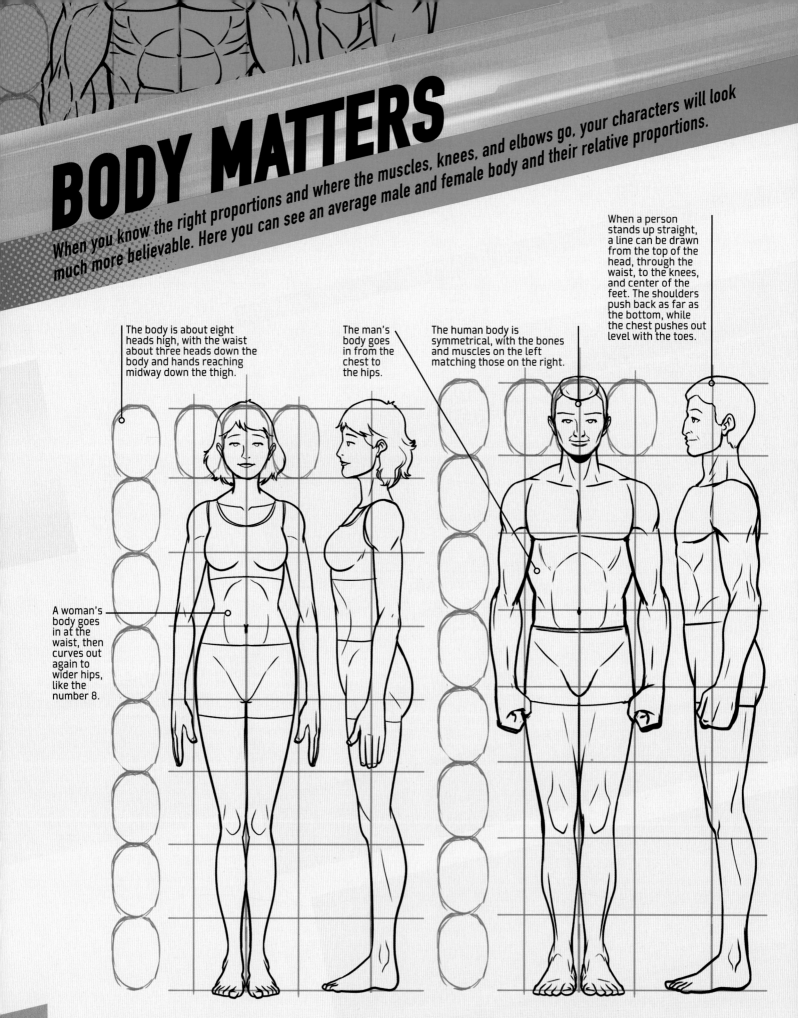

The body is about eight heads high, with the waist about three heads down the body and hands reaching midway down the thigh.

The man's body goes in from the chest to the hips.

The human body is symmetrical, with the bones and muscles on the left matching those on the right.

When a person stands up straight, a line can be drawn from the top of the head, through the waist, to the knees, and center of the feet. The shoulders push back as far as the bottom, while the chest pushes out level with the toes.

A woman's body goes in at the waist, then curves out again to wider hips, like the number 8.

Superheroes have exaggerated, muscular physiques, with broader shoulders, necks, and chests, but the head-to-body ratio, and arm and leg lengths should remain the same.

Get familiar with the position and shape of the muscles on the body, so that you can draw them from memory at different angles.

TOP TIP
You don't have to give all of your comic book characters an athletic build. Use different heights and body shapes so that readers find it easier to tell them apart.

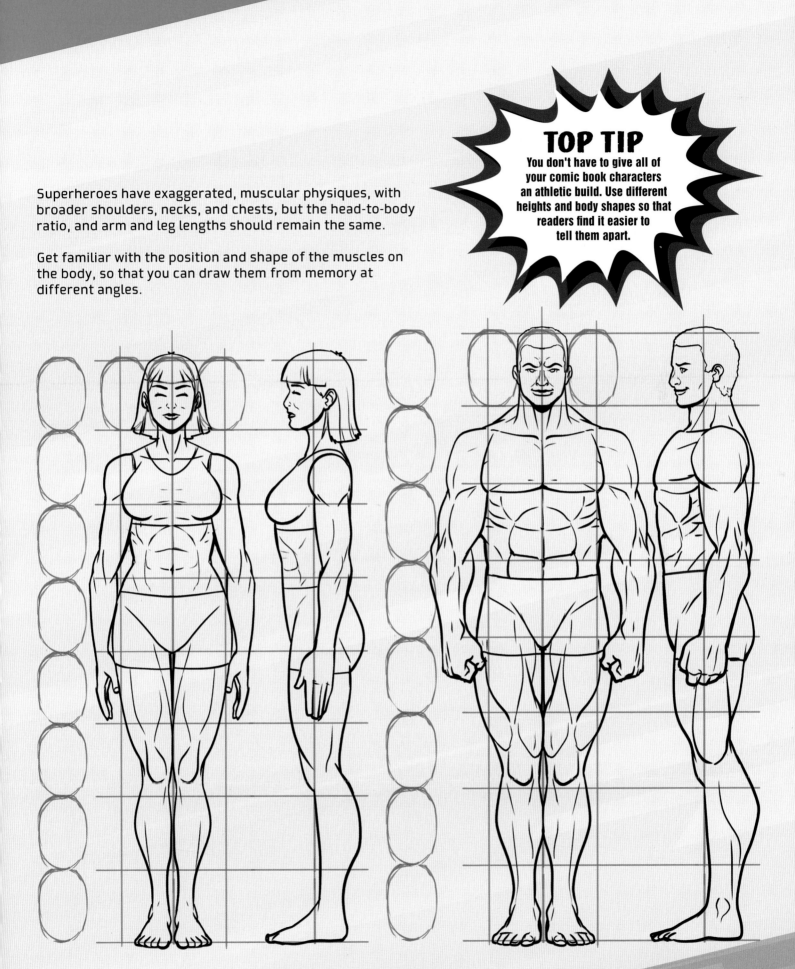

FACE TIME

Faces have their own proportions, with eyes and ears about halfway down the head. Here are average male and female faces you can use for reference.

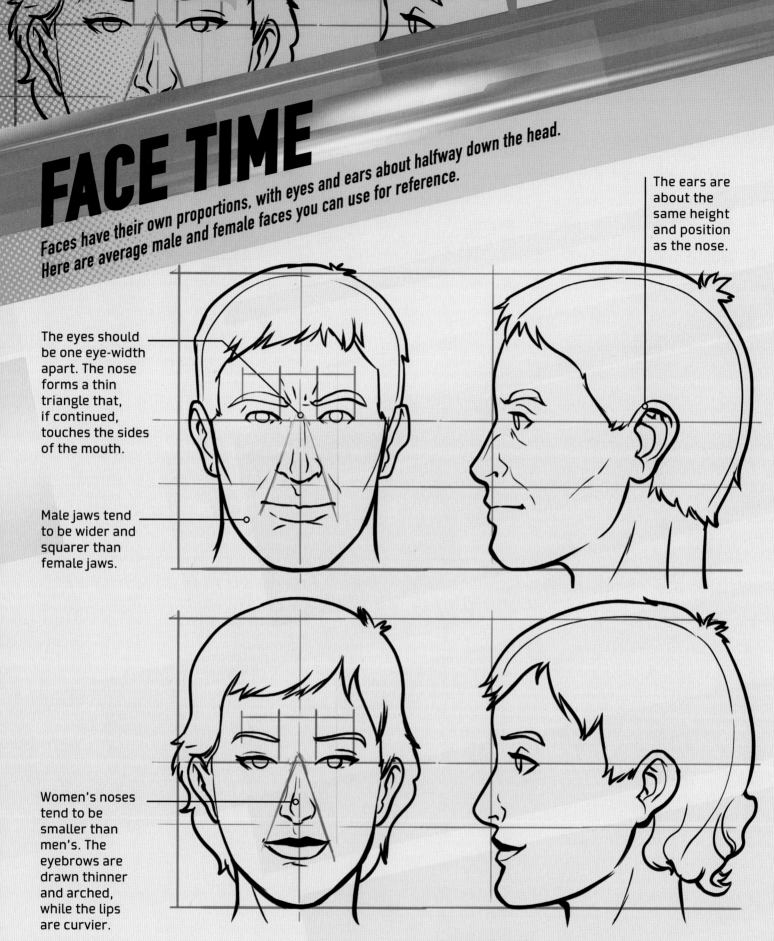

The ears are about the same height and position as the nose.

The eyes should be one eye-width apart. The nose forms a thin triangle that, if continued, touches the sides of the mouth.

Male jaws tend to be wider and squarer than female jaws.

Women's noses tend to be smaller than men's. The eyebrows are drawn thinner and arched, while the lips are curvier.

Look at the faces of friends and family. You will see many variations. Sketch details you see, and study hairstyles which you can use to make each of your comic characters unique.

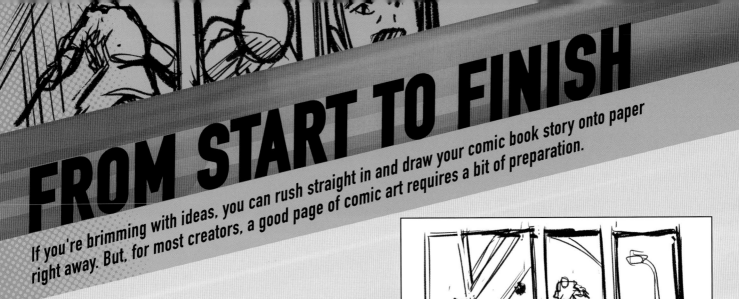

FROM START TO FINISH

If you're brimming with ideas, you can rush straight in and draw your comic book story onto paper right away. But, for most creators, a good page of comic art requires a bit of preparation.

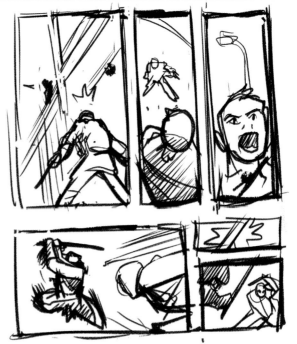

PANEL 1 - THE VILLAIN AUTOMATOR - INDIAN MALE, IN HI-TECH UNIFORM COVERED IN SENSORS AND DIGITAL READOUTS - DRIVES A ROBOTIC TANK THROUGH MANHATTAN, CAUSING DESTRUCTION. THE TANK HAS A BULLDOZER-LIKE VICE AT THE FRONT, POWERED BY HYDRAULICS, AND TWO ROBOTIC ARMS. ONE ROBOT ARM THROWS A CHUNK OF DEBRIS AT THE HERO MAMMOTH, KNOCKING HIM DOWN. SPACE FOR DIALOGUE FROM AUTOMATOR - WHO IS IN THE TANK'S DRIVING SEAT.

PANEL 1 DIALOGUE:
AUTOMATOR: CATCH!
MAMMOTH: OOF!

2. THUMBNAILS

Now the page can be mapped out. These first small, rough sketches for page layouts are called **THUMBNAILS**. When you're happy with the layout, you can move to a larger sheet of paper and prepare for the finished artwork.

1. THE SCRIPT

First write your story, with notes on the action that will take place on each page. The characters who appear in the adventure will need to be thought out. What do they look like, what do they wear, and how do they behave?

3. THE PANELS

The panels are lightly ruled on the page and the positions for **SPEECH BALLOONS** marked out. The penciling for each panel begins. You can start wherever you like on the page.

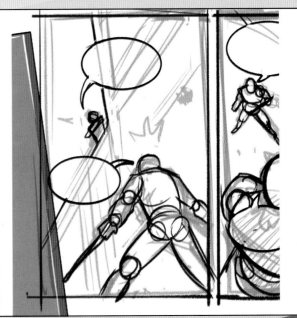

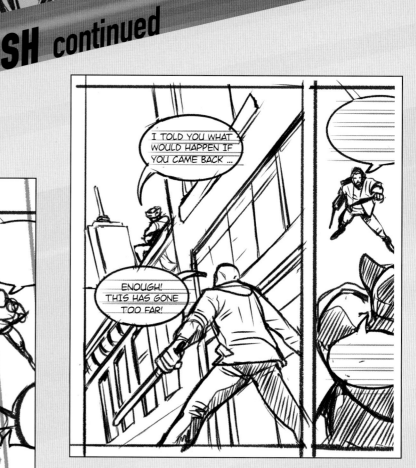

5. PENCILS

The final pencil sketches are drawn. Ruled lines are added to the speech balloons and the dialogue is written to make sure enough space is left for it.

4. PERSPECTIVE

Guidelines for **PERSPECTIVE** help create a 3D environment for many scenes. You can start drawing your characters as stick figures so that you get their pose and position right.

6. THE PANELS

The pencils are inked with a pen or brush, including the outlines for the panels and speech balloons. Once the ink is dry, the pencil lines can be erased. Finally, it's time for the colors ... and the job is done!

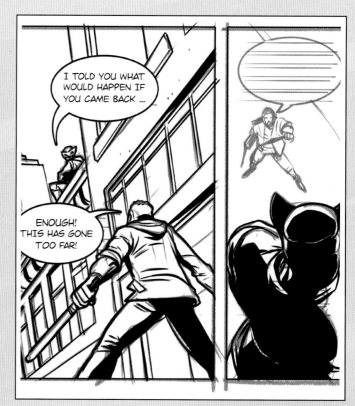

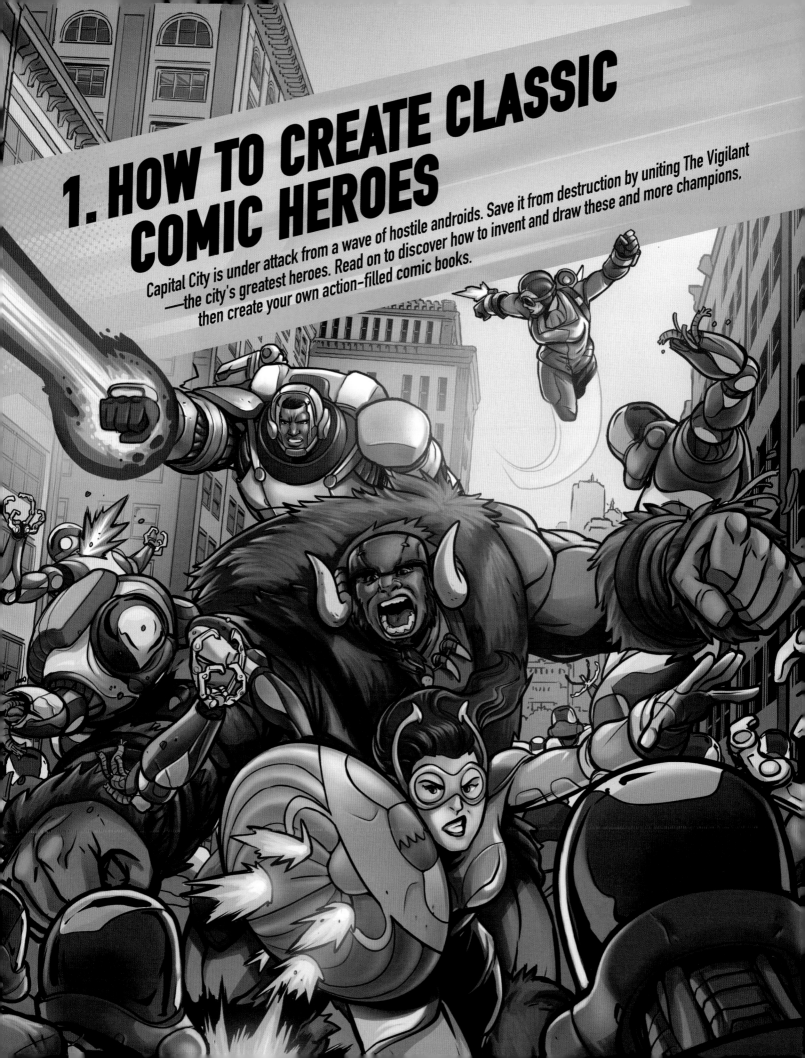

1. HOW TO CREATE CLASSIC COMIC HEROES

Capital City is under attack from a wave of hostile androids. Save it from destruction by uniting The Vigilant —the city's greatest heroes. Read on to discover how to invent and draw these and more champions, then create your own action-filled comic books.

HEROES IN THE MAKING

What makes a great comic book superhero? Here are our design notes for four new characters, plus some guidelines on how you can use these principles for creating your own superheroes.

CHARACTER CONCEPT

What is the basic concept for your character? Mammoth is a hero from the Ice Age. He has a lot to learn about the modern day ... not least, how to behave politely!

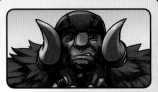

NAME: MAMMOTH

REAL IDENTITY: Grurrn

POWERS: Super-strength, resilience, and fast healing.

ORIGIN: A super-strong hunter discovered in a glacier after being frozen during the last Ice Age. His powers come from an ancient mammoth god.

STRENGTH	◇◇◇◇◇
INTELLIGENCE	◇◇◇◇◇
SPECIAL POWERS	◇◇◇◇◇
FIGHTING SKILLS	◇◇◇◇◇

COSTUME

A hero's costume should logically follow from their character concept. Mammoth's costume gives him a wild and primitive look. The helmet is a reminder of his connection to the tusked mammoth god.

TOP TIP
You can find design inspiration in the past and the present. Golden Dart has a retro look based on a 1930s pilot, brought up to date with some modern tech.

MOTIVATION
Why does your hero choose to fight crime? Golden Dart is haunted by the loss of her mother. Many heroes choose to tackle villains after witnessing a tragedy or to make up for a past mistake. Giving your character a strong reason for being a superhero will make them more compelling.

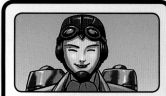

NAME: GOLDEN DART

REAL IDENTITY: May Tang

POWERS: Flight. Wristbands fire explosive darts.

ORIGIN: May always wanted to be a hero like her mother, the first Golden Dart. After her mom died at the hands of the ghastly Mr. Morbid, May designed a similar costume with upgraded weapons to take down his criminal empire.

STRENGTH ◆◇◇◇◇
INTELLIGENCE ◆◆◆◇◇
SPECIAL POWERS ◆◇◇◇◇
FIGHTING SKILLS ◆◆◆◇◇

COSTUME COLORS
Why does your hero dress in a particular way? Golden Dart's brown and tan outfit shows her origins as a legacy hero. However, your hero might want to make a bold statement with bright colors or wear dark hues to hide in the shadows at night.

CHARACTER DYNAMICS
How do your characters relate to one another? While Golden Dart may look like a blast from the past, she's a modern woman, with technological know-how and a quick wit—the opposite of Ice-Age Mammoth. There's a real culture clash when the pair meet.

TOP TIP

When you assemble a superteam, choose heroes with diverse powers, so they each add something to the group. Not every teammate has to be strong or clever.

SUPER POWERS

Your hero may be a mutant, born with incredible powers. They may have gained them through science or mystical means—maybe by accident. Or they may be strong, athletic, and resourceful through hard work and determination.

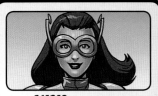

NAME: SCARAB

REAL IDENTITY: Rosa Ramirez

POWERS: Super senses, gymnastic ability, tracker.

ORIGIN: Framed for crimes she didn't commit, Rosa spent months in solitary confinement. In her cell, she was bitten by mutant beetles. This caused her to develop an uncanny ability to communicate with insects. Freed, she used her super senses to track down those who framed her.

STRENGTH ◆◆◇◇◇
INTELLIGENCE ◆◆◆◇◇
SPECIAL POWERS ◆◆◇◇◇
FIGHTING SKILLS ◆◆◆◆◇

INSPIRATION

Nature is a great place to look for ideas for super characters. Scarab is named after a large, tough beetle. Names, powers, and costumes can be inspired by animals, plants, or even the weather!

SECRET IDENTITY

Who is your hero when he or she isn't fighting villains? Shellshock is an army veteran. After being betrayed by his own commanding officer, he finds it hard to trust anyone.

HEROIC FLAWS

For your hero to be interesting, they will need problems to overcome. Shellshock may be tough and smart, but when out of his armor, he is paralyzed from the neck down.

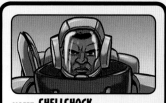

NAME: SHELLSHOCK

REAL IDENTITY: Roy Martin

POWERS: Wears strong defensive armor with built-in weapons and computer interface.

ORIGIN: When this gifted army engineer was injured in combat, he knew he had to do more. While his "Hardshell" tech protects troops, Roy guards his home city as an armored superhero.

STRENGTH ◆◆◆◆◇◇
INTELLIGENCE ◆◆◆◆◇◇
SPECIAL POWERS ◆◆◆◇◇◇
FIGHTING SKILLS ◆◆◆◇◇◇

STRIKE A POSE

Here are the basics for drawing a hero in a dynamic pose, ready for action.

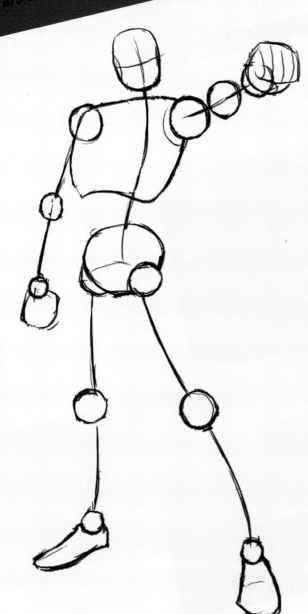

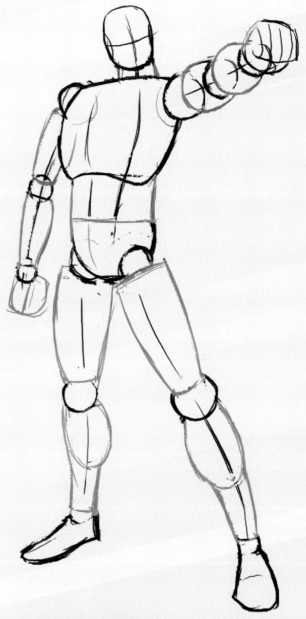

1. WIREFRAME

Using light pencil marks, draw a simple stick figure showing your hero's pose, with circles for joints. Make the pose dramatic, but be sure that the proportions are correct.

2. BLOCK FIGURE

Use basic shapes to fill out your figure: an oval head, a rounded torso that goes in toward the waist, and cylindrical arms and legs. The figure's left arm seems short but gets wider the closer it is to the viewer. This effect is called **FORESHORTENING**.

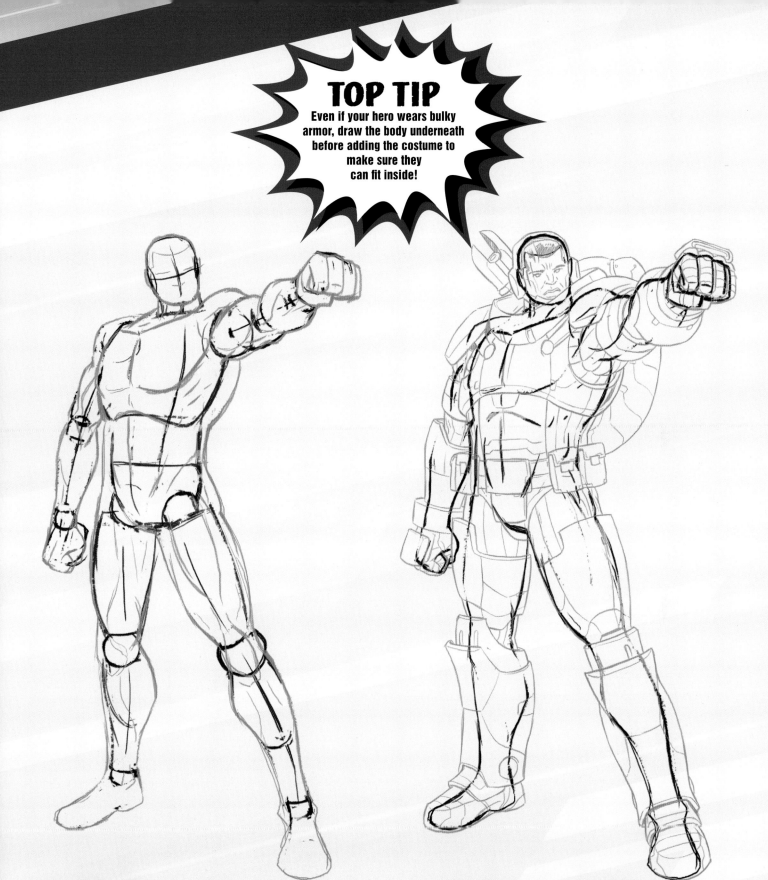

TOP TIP
Even if your hero wears bulky armor, draw the body underneath before adding the costume to make sure they can fit inside!

3. ANATOMY
Add flesh to your hero. Replace the body blocks with more accurate anatomy, muscles, and joints. Reshape the hands and feet, adding fingers. Carefully erase your original construction lines.

4. FINISHED PENCIL SKETCHES
Now tighten your pencil sketches. Add facial features. Finally, draw costume details, including any mask, armor, weapons, and tech. You can see how Shellshock's armor encases his body.

5. INKS

Using a fine brush or pen, go over your pencil sketches, keeping the lines you want to show on the finished figure. When the ink is dry, use an eraser to rub out your pencil lines. Notice how the ink line becomes slightly wider over the more dominant parts of the armor.

EXAGGERATE!

Compare these two figures in a defensive pose. Figure 1 is realistic but not very exciting. The hero looks hesitant with his limbs close together. Figure 2 is better. He has a more dramatic pose, with shoulders back, legs wider apart, and arms reaching out. He looks confident, as a superhero should.

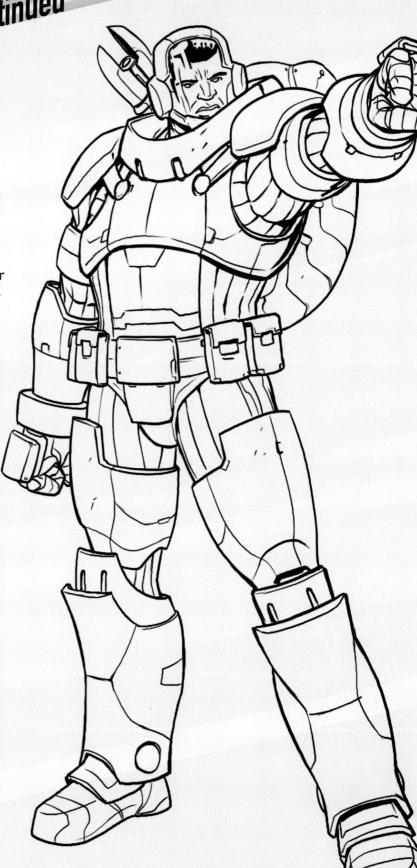

6. COLORS

Superheroes tend to have costumes in bold primary colors—red, blue, and yellow. Different tones emphasize the curves and shine on Shellshock's armor. His suit is clean and polished, adding to his heroic appearance.

HERO COLORS

VILLAIN COLORS

TOP TIP
Don't add too many colors to your hero or villain's costume. Two contrasting or complementary colors work best!

RACING INTO ACTION

Time to get your hero off the starting blocks. Here's how to draw a character running forward into action—heroes never run away from danger, of course!

NAME: SPRINT

REAL IDENTITY: Tyra Dupree

POWERS: Super speed.

ORIGIN: After lab assistant Tyra was exposed to a temporal-dilation experiment, she experiences time at a different speed. To her, she is not fast—but everything else is slow!

STRENGTH ◆◇◇◇◇
INTELLIGENCE ◆◆◆◇◇
SPECIAL POWERS ◆◆◆◆◇
FIGHTING SKILLS ◆◆◆◇◇

1. Sprint leans dramatically in the direction she is racing, with her torso twisted at right angles to her waist. Her left arm is pushing forward, while her left leg is behind, and vice versa for her right-hand limbs.

2. With her body leaning over, we see her shoulders and chest from above, with her torso getting thinner to her waist. Just as on a real human body, the 3D shapes used to build her form are not straight but slightly curved.

➤ In the finished, inked figure, see how the parts of the body that are closest to the reader have a thicker outline than those further back. This subtle difference helps to add depth to the image.

3. As you tighten the pencil sketches, you can define the muscles on Sprint's figure. The muscles on her left arm are slightly rounder than those on her right arm, as they pull her forearm up. Elbows and knees stand out more as the joints are bent.

4. With a racing figure, like Sprint, use a ruler to add speed lines radiating from the point she is running from, to show her movement.

TAKING OFF

How should you draw a flying character? Charge is an electrically powered hero launching himself into the stratosphere. Find out how you can make him really leap from the page.

NAME: **CHARGE**

REAL IDENTITY: Brad Beckerman

POWERS: Control of electricity, flight; electrical body held together by willpower.

ORIGIN: Construction engineer Brad Beckerman was caught in a freak lightning storm that disintegrated his body but left his mind intact. He now exists as an electrical charge in a high-tech containment suit.

STRENGTH	◈◈◇◇◇
INTELLIGENCE	◈◈◇◇◇
SPECIAL POWERS	◈◈◈◈◇
FIGHTING SKILLS	◈◈◇◇◇

1. Our flying hero—Charge— is propeling himself upward from a rooftop to take flight. One leg is bent as he pushes up, but the rest of his body is stretching into the sky.

2. This character has a classic superhero body—muscular with wide shoulders and a large chest like a bodybuilder. His hands are reaching toward us, so that they appear bigger than his head. The whole figure forms a slim triangle.

TOP TIP
Of course, a flying hero doesn't have to jet away with arms outstretched, but it's much more dramatic to have him reaching forward to adventure!

3. Draw the face and hands, then pencil in the anatomy from the arms toward the feet, deciding which muscles and joints will cover those farther back in the figure.

TOP TIP

While Charge's figure points in one direction, his cape curves around him in the wind, adding a nice contrast to his more rigid body.

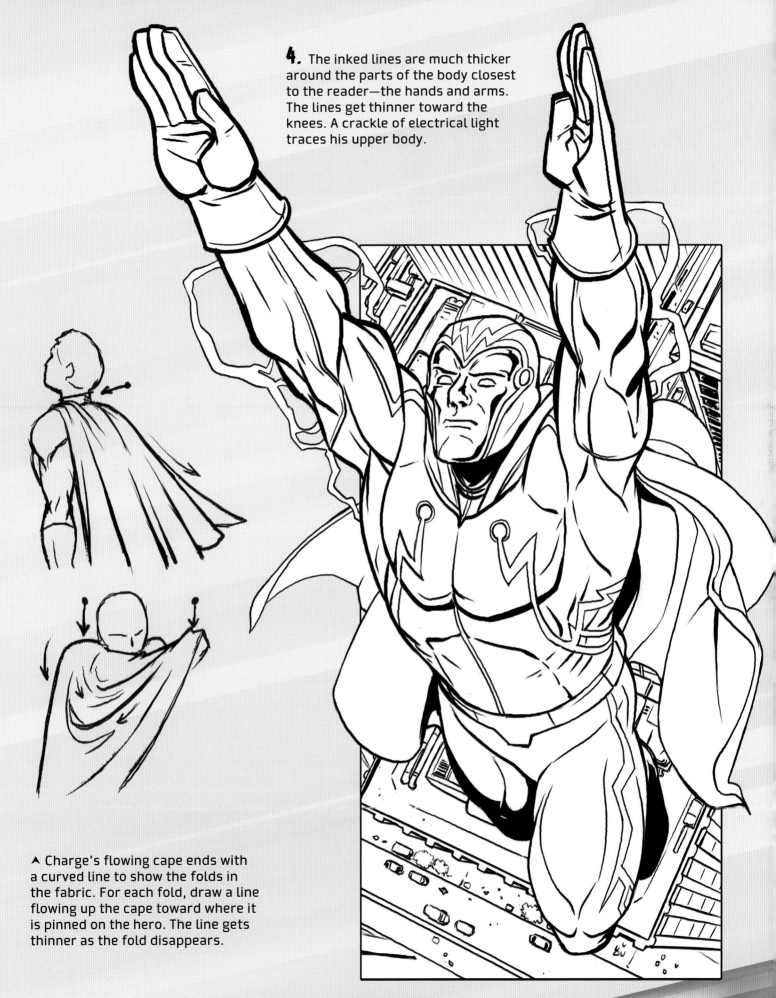

4. The inked lines are much thicker around the parts of the body closest to the reader—the hands and arms. The lines get thinner toward the knees. A crackle of electrical light traces his upper body.

▲ Charge's flowing cape ends with a curved line to show the folds in the fabric. For each fold, draw a line flowing up the cape toward where it is pinned on the hero. The line gets thinner as the fold disappears.

IT'S A HIT!

Now you're ready to lead your heroes into battle and throw a first punch.

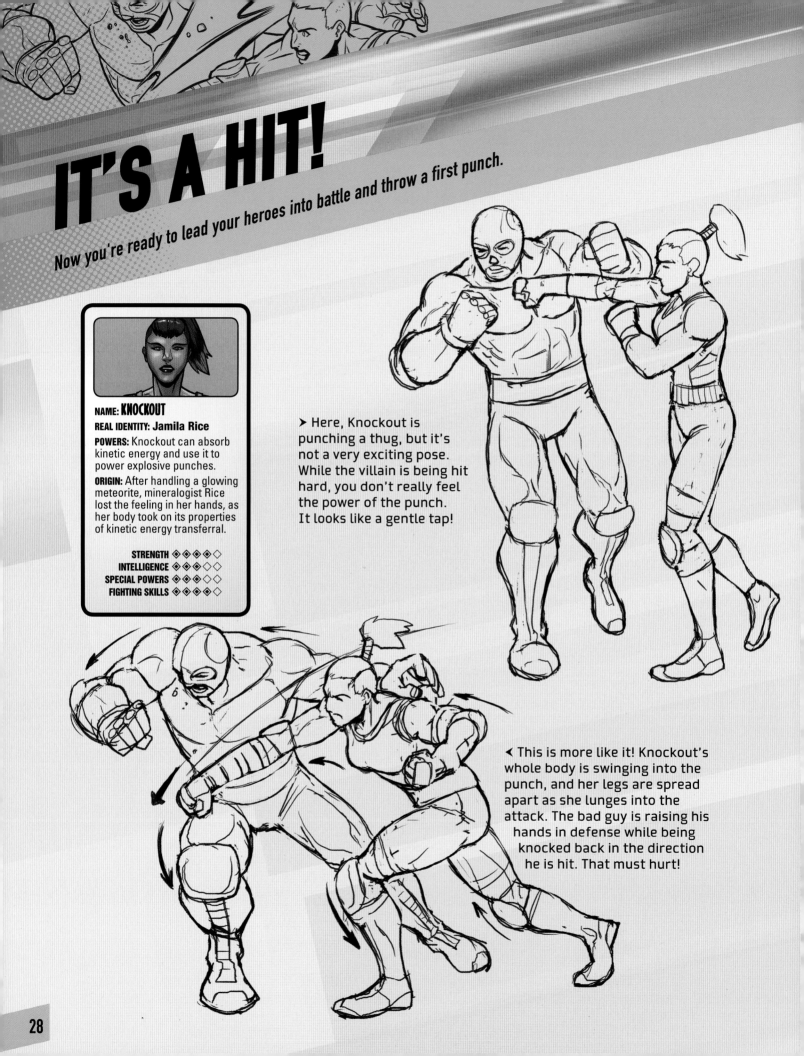

NAME: KNOCKOUT

REAL IDENTITY: Jamila Rice

POWERS: Knockout can absorb kinetic energy and use it to power explosive punches.

ORIGIN: After handling a glowing meteorite, mineralogist Rice lost the feeling in her hands, as her body took on its properties of kinetic energy transferral.

STRENGTH ◆◆◆◆◇
INTELLIGENCE ◆◆◆◇◇
SPECIAL POWERS ◆◆◆◇◇
FIGHTING SKILLS ◆◆◆◆◇

➤ Here, Knockout is punching a thug, but it's not a very exciting pose. While the villain is being hit hard, you don't really feel the power of the punch. It looks like a gentle tap!

◀ This is more like it! Knockout's whole body is swinging into the punch, and her legs are spread apart as she lunges into the attack. The bad guy is raising his hands in defense while being knocked back in the direction he is hit. That must hurt!

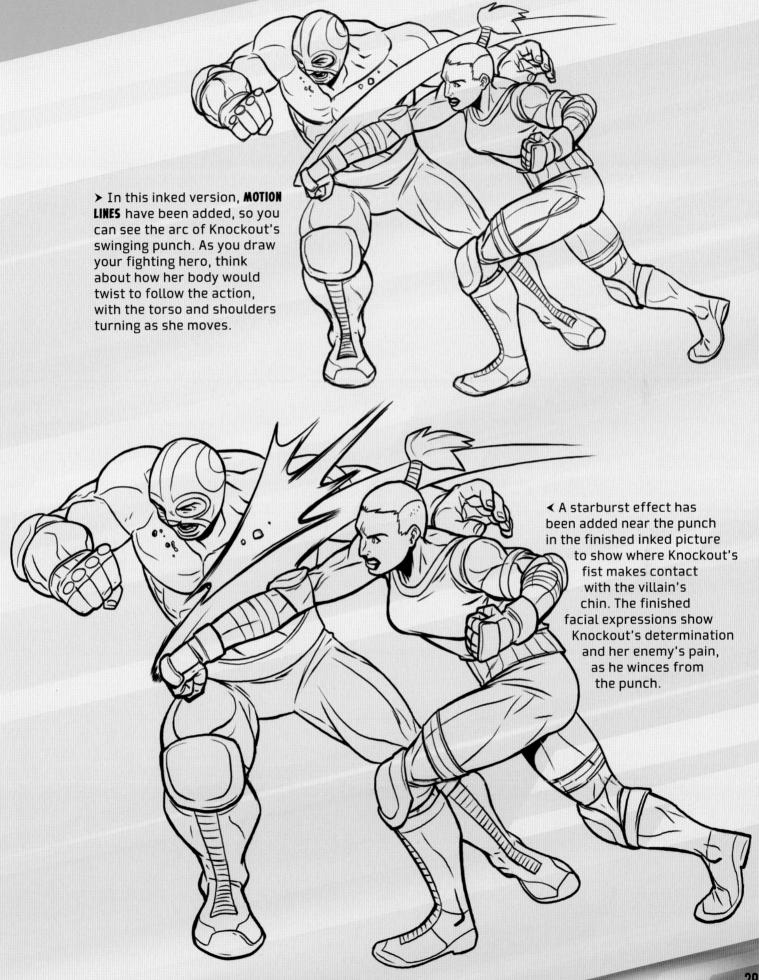

> In this inked version, **MOTION LINES** have been added, so you can see the arc of Knockout's swinging punch. As you draw your fighting hero, think about how her body would twist to follow the action, with the torso and shoulders turning as she moves.

◄ A starburst effect has been added near the punch in the finished inked picture to show where Knockout's fist makes contact with the villain's chin. The finished facial expressions show Knockout's determination and her enemy's pain, as he winces from the punch.

PLANNING THE PAGE

Now that you have the basics of drawing your heroes in action, it's time to plan a comic page with more than one panel. The scene shows the hero Mammoth in conflict with evil genius Automator.

◄ This is a **THUMBNAIL**—a small, rough plan of the comic page. A variety of views, from wide-open shots to close-ups, should be used on the page to make it exciting. There are six panels leading to the big event when Mammoth breaks free. The action should lead your eye toward this point.

NAME: AUTOMATOR

REAL IDENTITY: Rohan Sen

POWERS: Superior robotics engineer.

ORIGIN: Sen used his scientific genius to build a helmet that would free his mind from human inefficiency. It turned him into a ruthless monster!

STRENGTH	◆◆◇◇◇
INTELLIGENCE	◆◆◆◆◇
SPECIAL POWERS	◆◆◆◇◇
FIGHTING SKILLS	◆◆◇◇◇

The first panel is an **ESTABLISHING SHOT**, to set the scene in downtown Capital City, showing Automator's machine approaching Mammoth.

Pale-blue ruled **PERSPECTIVE LINES** help the artist to draw buildings at the correct angle.

THUMBNAILS

Comic book artists use loose thumbnail sketches to plan each page. They may try several versions, with enough drama and contrast, until they are happy that the page works. Changes can be made to the page design right up to the inking stage.

Panel 2 is a **MEDIUM SHOT** from Automator's point of view, showing all of Mammoth's body.

Panel 3 is a close-up of the evil villain.

◀ Even when there's a lot to draw, don't forget to allow space for the characters' dialogue. **Speech balloons** can take up about a third of the panel; they are usually placed along the top.

➤ Mammoth looks like he's going to be squashed by the machine. The view of the hero gets tighter, too, so you can feel the pressure he is under and see the struggle in his face.

➤ The finished inked page has a lot of drama, with every panel pulling you through the story. The shaded areas have been filled in black. Extra background detail has been added to some panels, along with some **MOTION LINES**, but not so much that it distracts from the main action.

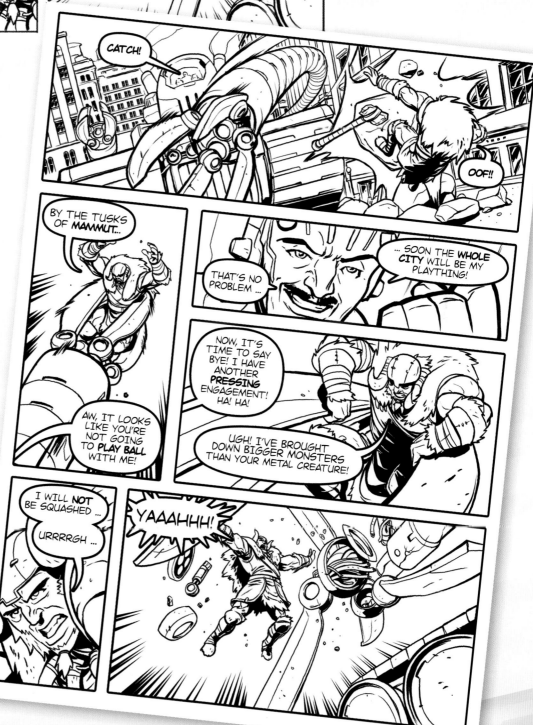

MAKING A SPLASH

While your comic book needs pages with lots of panels to tell the story, sometimes it's best to break out of the borders and draw a scene that fills the whole page! This is called a splash panel.

1. Capital City's finest heroes, The Vigilant, have gathered to combat the alien Amoeboid before it consumes all around it! The rough plan for this scene places the four heroes in and around the beast. Shellshock is closest to us so that he appears the largest.

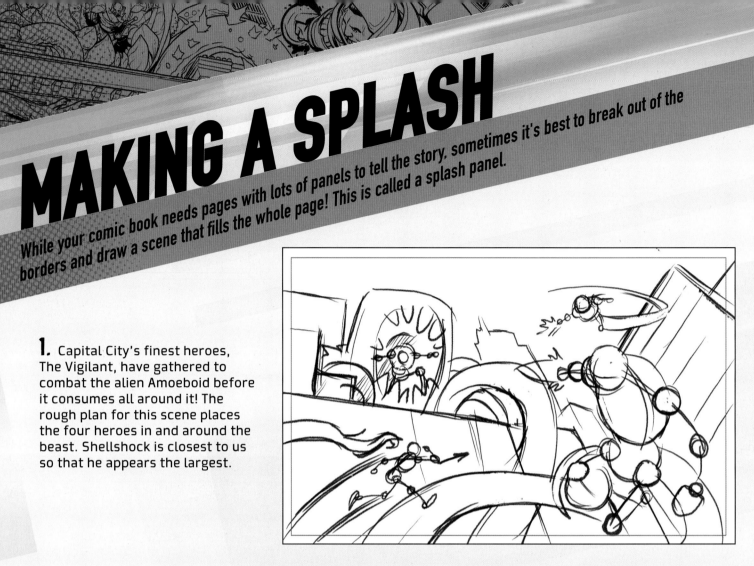

2. Ruled **PERSPECTIVE LINES** show the angles of the buildings in the background. Our point of view on the action is looking up at the creature, from near ground level.

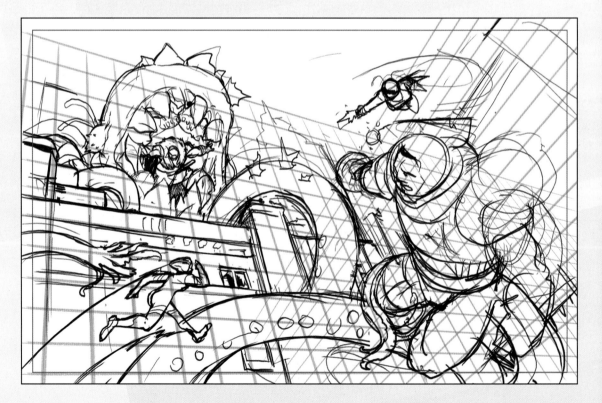

3. The pencil sketches show more clearly how the heroes are interacting with one another and the alien. While most of The Vigilant are looking at the Amoeboid and its tentacles, they should also be keeping an eye on their teammates and reacting to one another visually, not just relying on dialogue to push the story forward.

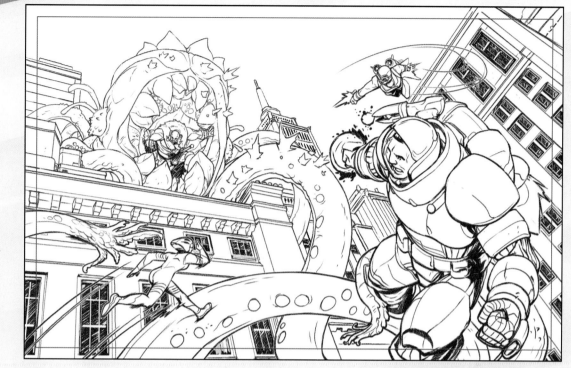

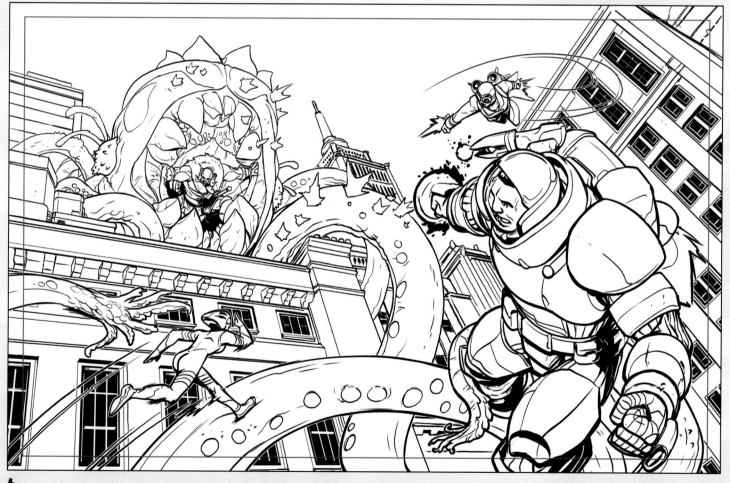

4. The final inked image draws your gaze toward the main action around the alien. Its curling tentacles contrast with the angular buildings and Shellshock's shiny armor.

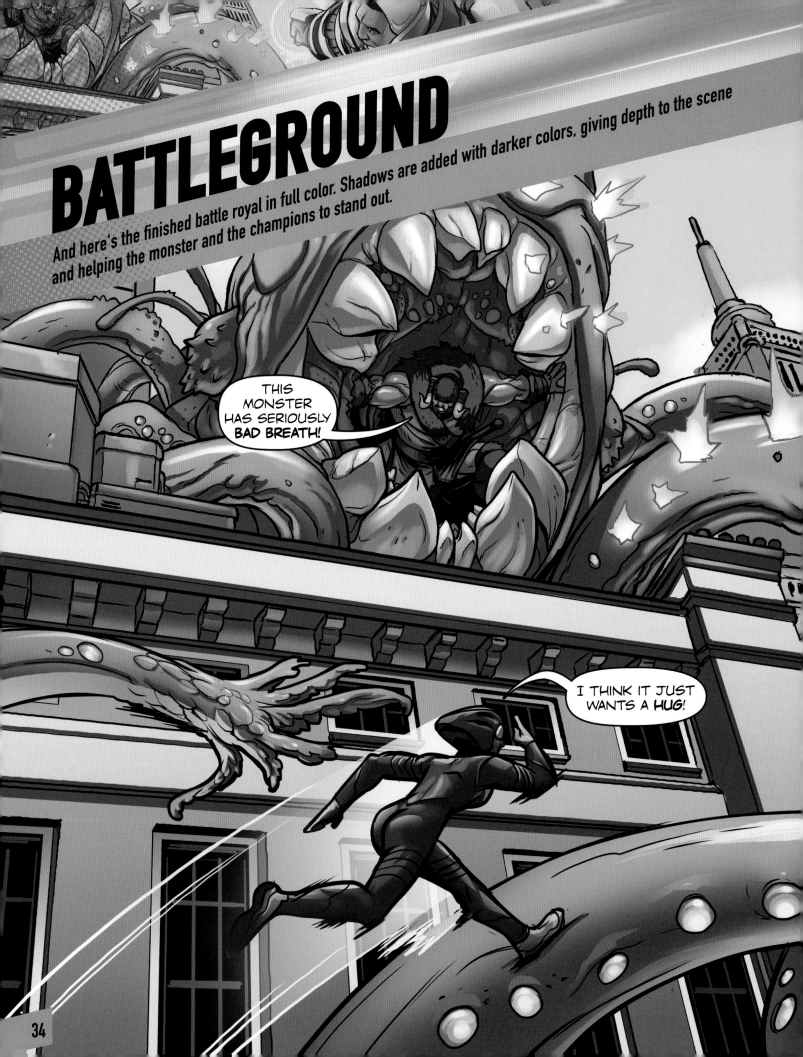

BATTLEGROUND

And here's the finished battle royal in full color. Shadows are added with darker colors, giving depth to the scene and helping the monster and the champions to stand out.

THIS MONSTER HAS SERIOUSLY BAD BREATH!

I THINK IT JUST WANTS A HUG!

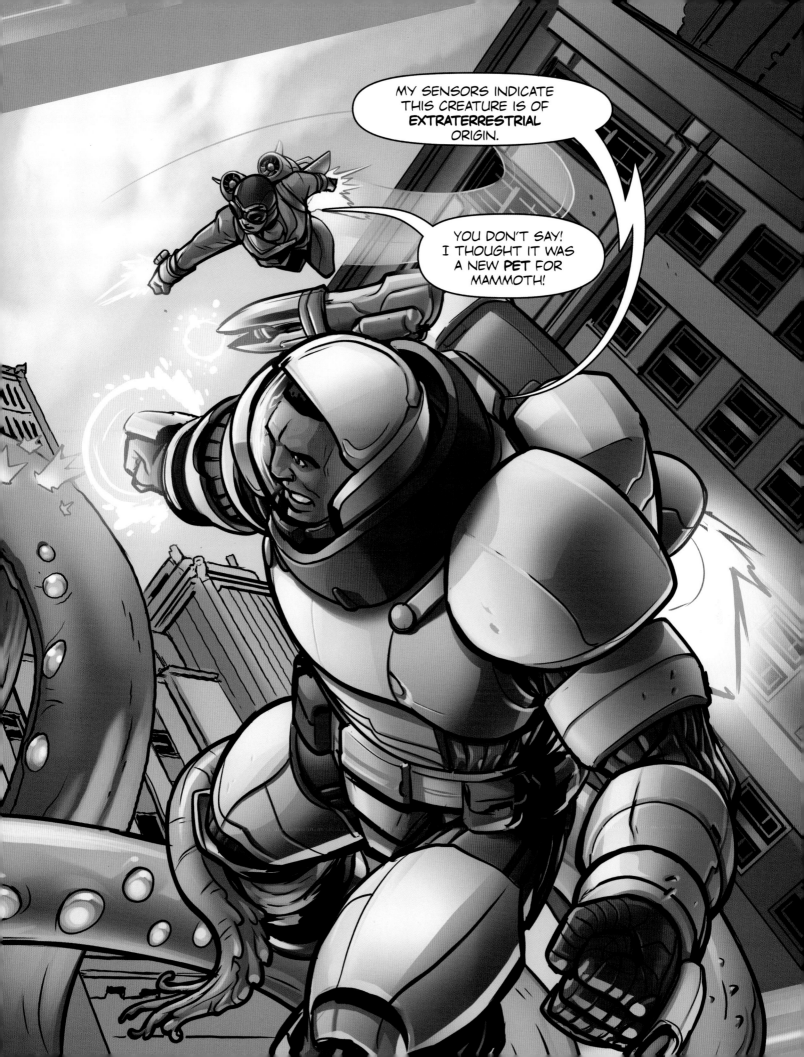

THE PERFECT PLOT

What do you need to create a satisfying adventure? Here are a few tips on writing a gripping comic book story.

ACT 1. THE SET UP

Characters are introduced, and a threat appears. The first part of your story introduces the setting and main characters before something dramatic happens to lead your heroes into danger. Give the villains a good reason to cause trouble—jealousy, revenge, a troubled past, or a craving for something they don't have.

ACT 2. THE CONFRONTATION

The hero investigates and ends up in danger. The villain should appear to be a genuine threat. Heroes often lose the battle on a first attempt and have to improve or discover a new way to defeat their foe. This provides a chance for **CHARACTER DEVELOPMENT**.

ACT 3. THE RESOLUTION

The hero finds a way to escape and save the day. While planning the set-up, think ahead to how your hero will escape. Don't make it obvious—say, by smashing her way out. Have your hero use her brain. The hero, and possibly the villain, should have learned something new by the end of the story.

TO BE CONTINUED!

Of course, you could always end with a **CLIFFHANGER** ... and hold off Act 3 till the next issue!

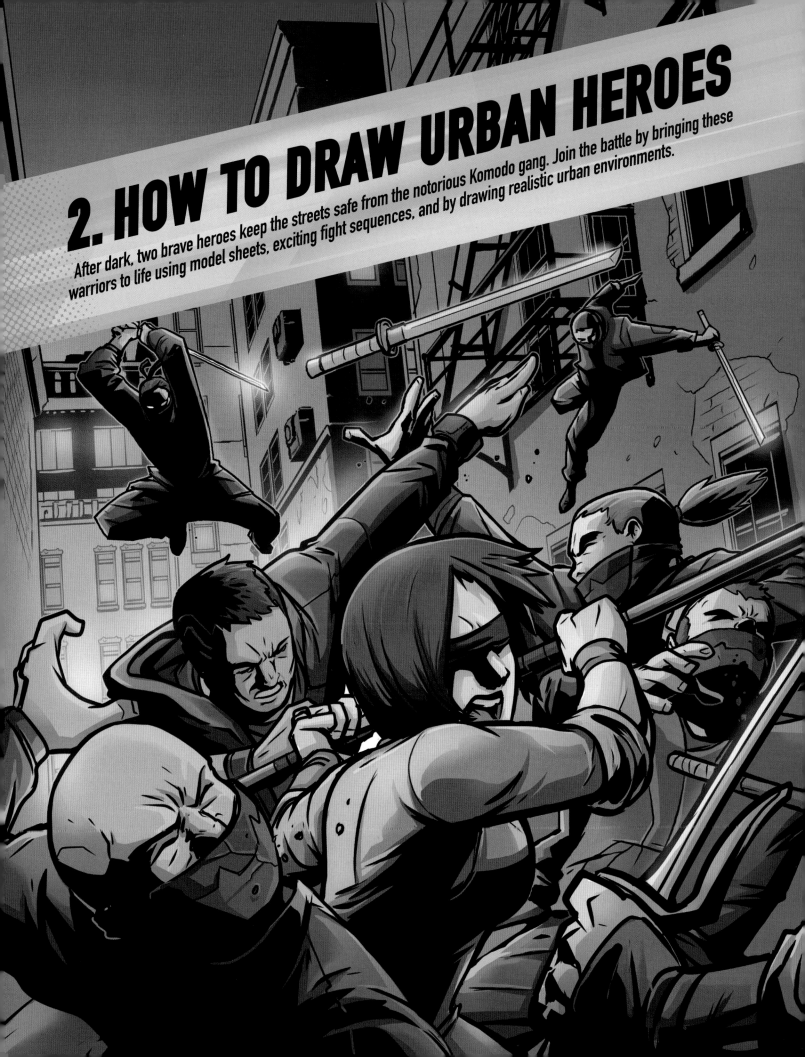

2. HOW TO DRAW URBAN HEROES

After dark, two brave heroes keep the streets safe from the notorious Komodo gang. Join the battle by bringing these warriors to life using model sheets, exciting fight sequences, and by drawing realistic urban environments.

MODEL SHEETS

When you've come up with some exciting new characters, you'll want to make sure you always draw them right. Create a Model Sheet, like this, to show your characters from the front, side, and rear, for reference.

These urban heroes are wearing a mix of street fashion and sports gear that allows them free movement for running through the night streets and tackling gangs. The clothes are cool but functional. Stealth and Blind Justice have no real super powers, but they are highly skilled and at the peak of fitness.

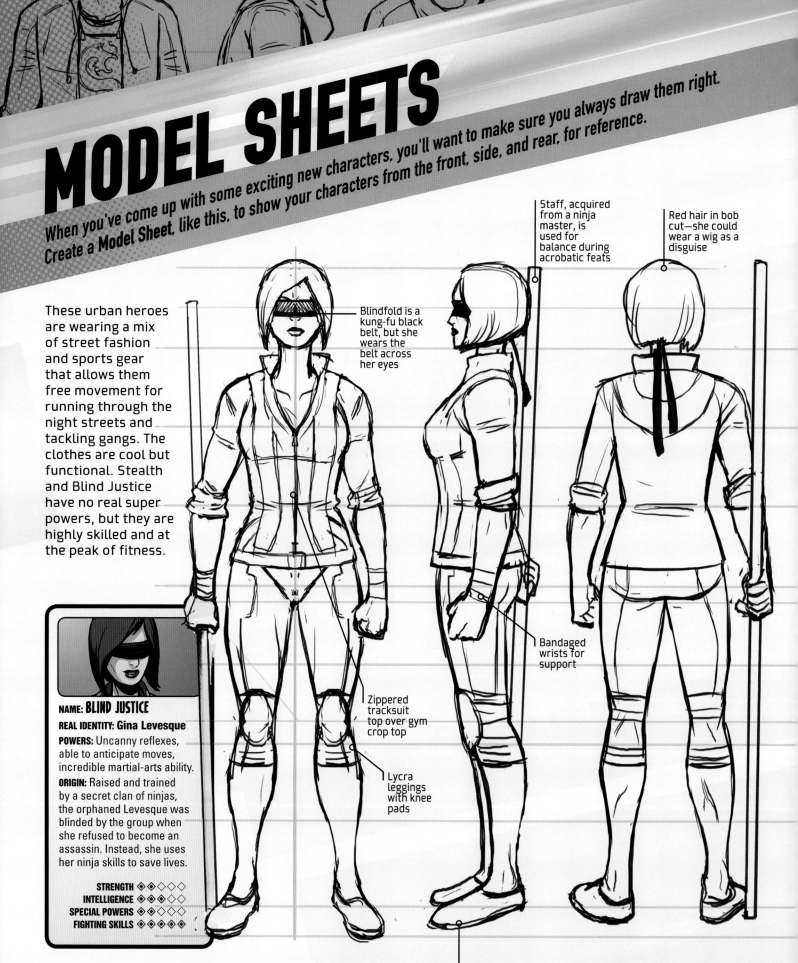

Staff, acquired from a ninja master, is used for balance during acrobatic feats

Red hair in bob cut—she could wear a wig as a disguise

Blindfold is a kung-fu black belt, but she wears the belt across her eyes

Bandaged wrists for support

Zippered tracksuit top over gym crop top

Lycra leggings with knee pads

Kung-fu pumps

NAME: BLIND JUSTICE

REAL IDENTITY: Gina Levesque

POWERS: Uncanny reflexes, able to anticipate moves, incredible martial-arts ability.

ORIGIN: Raised and trained by a secret clan of ninjas, the orphaned Levesque was blinded by the group when she refused to become an assassin. Instead, she uses her ninja skills to save lives.

STRENGTH ◆◇◇◇◇
INTELLIGENCE ◆◆◆◇◇
SPECIAL POWERS ◆◆◇◇◇
FIGHTING SKILLS ◆◆◆◆◇

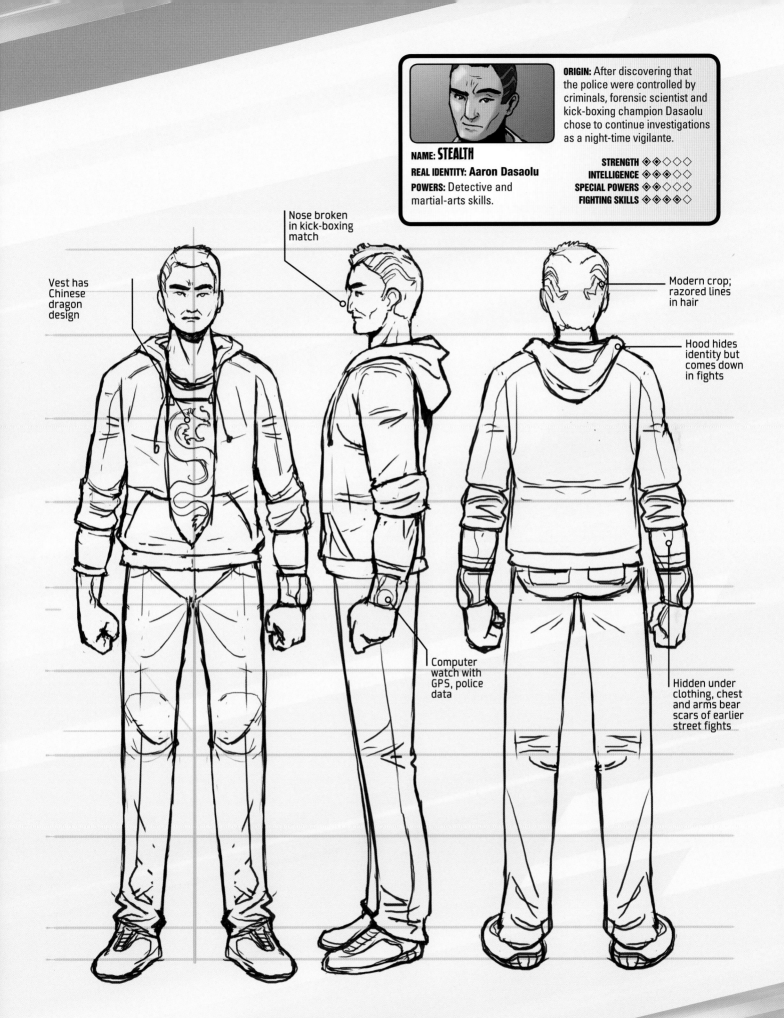

ORIGIN: After discovering that the police were controlled by criminals, forensic scientist and kick-boxing champion Dasaolu chose to continue investigations as a night-time vigilante.

NAME: **STEALTH**

REAL IDENTITY: **Aaron Dasaolu**

POWERS: Detective and martial-arts skills.

STRENGTH ◆◆◇◇◇
INTELLIGENCE ◆◆◆◆◇
SPECIAL POWERS ◆◇◇◇◇
FIGHTING SKILLS ◆◆◆◆◇

Vest has Chinese dragon design

Nose broken in kick-boxing match

Modern crop; razored lines in hair

Hood hides identity but comes down in fights

Computer watch with GPS, police data

Hidden under clothing, chest and arms bear scars of earlier street fights

MARTIAL ARTIST

When drawing a martial-arts hero, you need to think like a martial artist, considering the pose carefully. Put your hero in a calm, disciplined, and balanced position, alert and ready to defend or strike.

NAME: GOLDEN LOTUS

REAL IDENTITY: Unknown

POWERS: Martial-arts mistress of Qi—able to sense life energy and locate weak points on any opponent.

ORIGIN: Said to be an incarnation of the Southern Dragon goddess, Golden Lotus has studied how to channel the beast's legendary power.

STRENGTH ◈◈◇◇◇
INTELLIGENCE ◈◈◈◈◇
SPECIAL POWERS ◈◈◈◈◇
FIGHTING SKILLS ◈◈◈◈◈

1. WIREFRAME

Using a pencil, lightly draw a stick figure showing your hero's action pose, with circles for each joint. Make sure the figure is correctly proportioned and balanced.

2. BLOCK FIGURE

Use basic shapes as the building blocks for the figure of Golden Lotus. Note how her shoulders tilt at the same angle as her raised arms, and her hands are at right angles to her arms.

TOP TIP
If you're not sure about a pose,
try holding the position yourself.
Does it feel natural?
Is there a better way to pose
your character?

3. ANATOMY
Lightly define Golden Lotus's slim and
muscular body. Once you have the
correct anatomy, you can sketch her
costume, making her gown's sleeves
hang off her arms.

4. FINISHED PENCIL SKETCHES
Complete the pencil sketches, adding
folds in Golden Lotus's gown that curve
away from her joints and where the
material is tucked in. Draw her trident
weapon attached by a strap and her
lotus-symbol belt.

41

BALANCING ACT

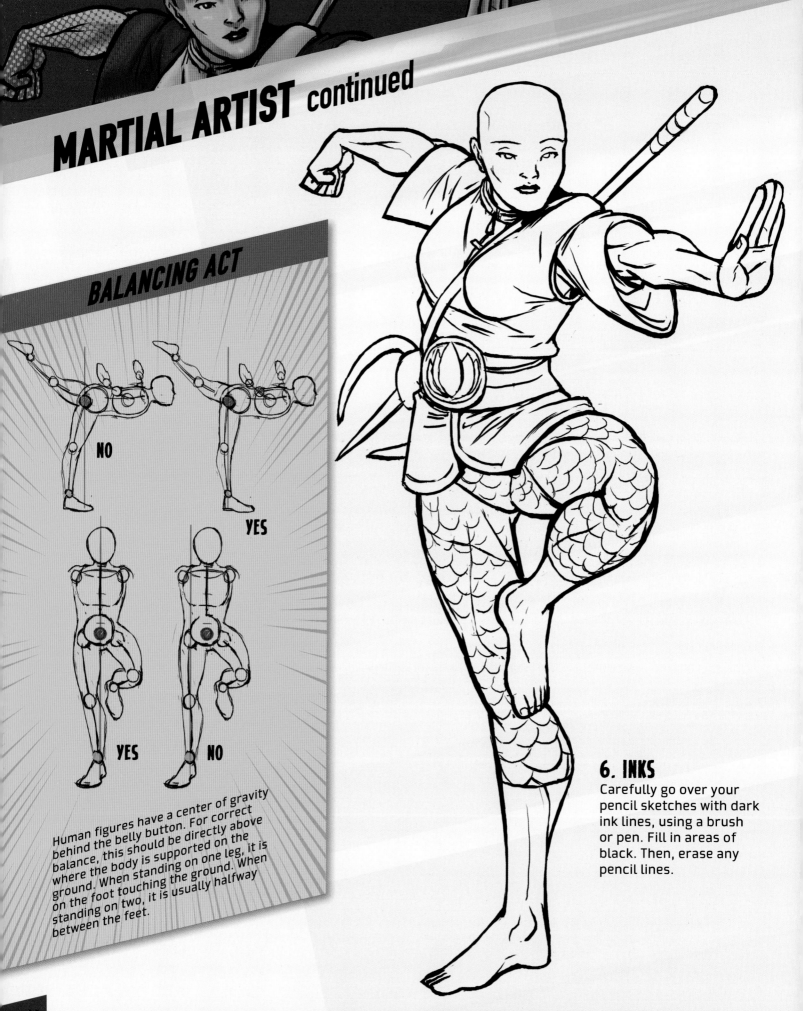

NO

YES

YES

NO

Human figures have a center of gravity behind the belly button. For correct balance, this should be directly above where the body is supported on the ground. When standing on the one leg, it is on the foot touching the ground. When standing on two, it is usually halfway between the feet.

6. INKS

Carefully go over your pencil sketches with dark ink lines, using a brush or pen. Fill in areas of black. Then, erase any pencil lines.

6. COLORS

Color in your figure, adding dark and light tones around the folds in the gown to make it appear more 3D. Golden Lotus wears colors that suggest action. She can spring into combat mode in a second.

TOP TIP

Golden Lotus's clothes resemble those worn by martial-arts students. Dress your heroes In appropriate clothing for their fighting technique, without fussy extras that get in their way.

MASTERING THE MOVES

When planning a hand-to-hand fight, imagine you are directing actors in a movie, with each responding to one another's moves. Follow the action as Blind Justice and Hooded Crane begin battle.

1. In this step, both fighters are assessing each other. They stand in defensive positions, deciding who will make the first move. Arms are raised, anticipating a strike from the opponent's hands.

NAME: HOODED CRANE

REAL IDENTITY: Jian Lau

POWERS: Martial-arts master with a grip it is impossible to break.

ORIGIN: Rejected as leader of a ninja clan in favor of Blind Justice, Crane has since sought to prove himself better by defeating his rival.

STRENGTH	◇◇◇◇◇
INTELLIGENCE	◇◇◇◇◇
SPECIAL POWERS	◇◇◇◇◇
FIGHTING SKILLS	◇◇◇◇◇

2. The fight is like a dance, with both characters taking a turn to lead the action. Hooded Crane strikes first, kicking with his right foot to try to knock Blind Justice off balance. But Justice expected this move and swings aside, moving her weight to her right.

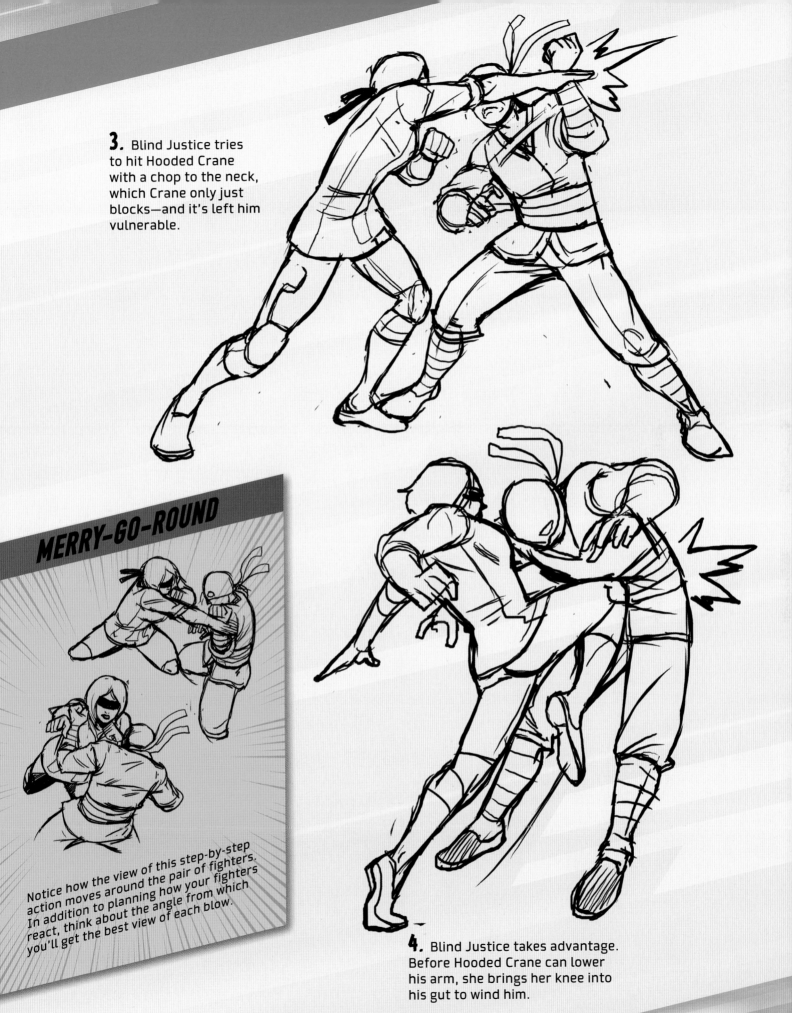

3. Blind Justice tries to hit Hooded Crane with a chop to the neck, which Crane only just blocks—and it's left him vulnerable.

MERRY-GO-ROUND

Notice how the view of this step-by-step action moves around the pair of fighters. In addition to planning how your fighters react, think about the angle from which you'll get the best view of each blow.

4. Blind Justice takes advantage. Before Hooded Crane can lower his arm, she brings her knee into his gut to wind him.

URBAN JUNGLE

A street-level hero needs a street. Here's how to use perspective lines to draw a realistic setting for your urban heroes and villains.

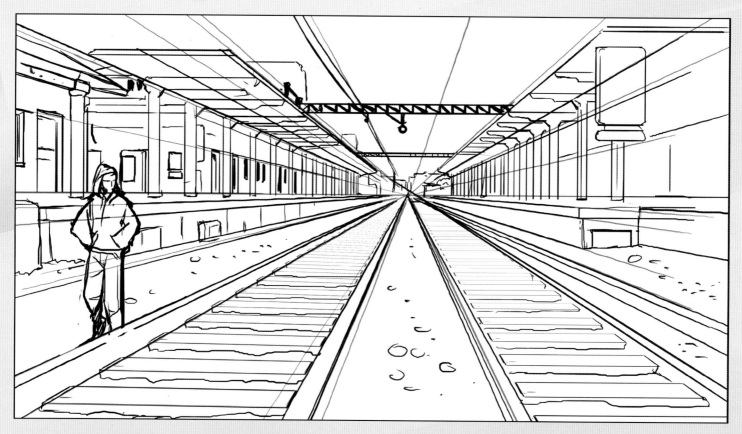

⌃ As objects get farther away, they appear smaller, like the rails on this track. The point at which the railroad track disappears is called the **VANISHING POINT**. The horizontal line in the distance, at the viewer's eye level, is called the **HORIZON LINE**.

TOP TIP
For practice, try adding ruled perspective lines to newspaper photos of buildings and streets. You'll soon become familiar with angles and horizons.

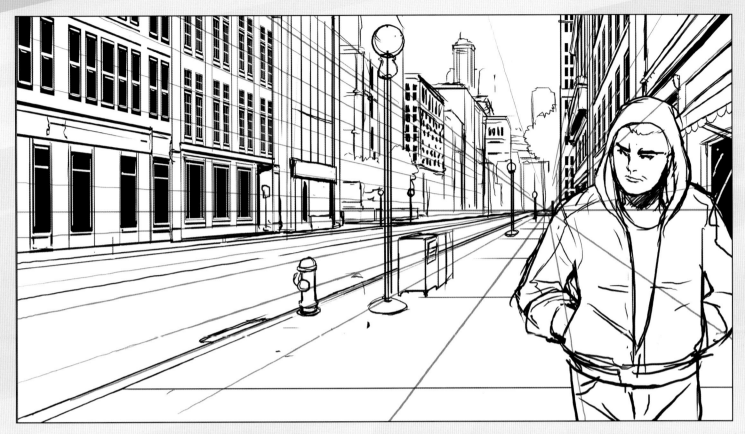

▲ In this street scene, **PERSPECTIVE LINES** drawn from the vanishing point on the horizon are used as guides to draw buildings and windows at the correct angle. This is a **ONE-POINT PERSPECTIVE**.

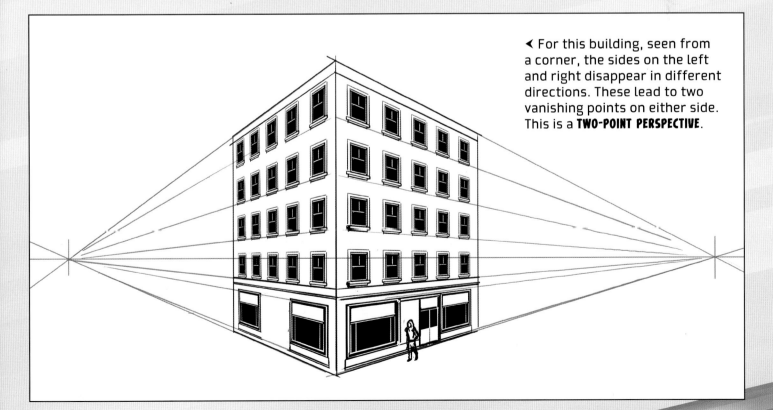

◄ For this building, seen from a corner, the sides on the left and right disappear in different directions. These lead to two vanishing points on either side. This is a **TWO-POINT PERSPECTIVE**.

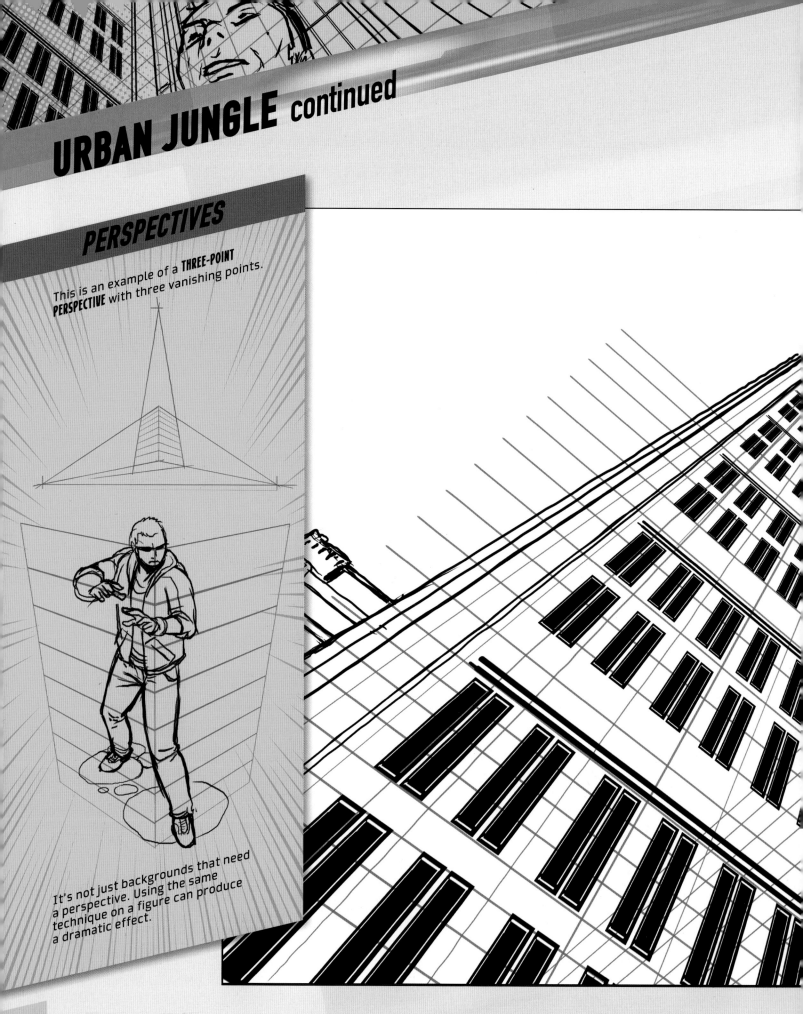

PERSPECTIVES

This is an example of a **THREE-POINT PERSPECTIVE** with three vanishing points.

It's not just backgrounds that need a perspective. Using the same technique on a figure can produce a dramatic effect.

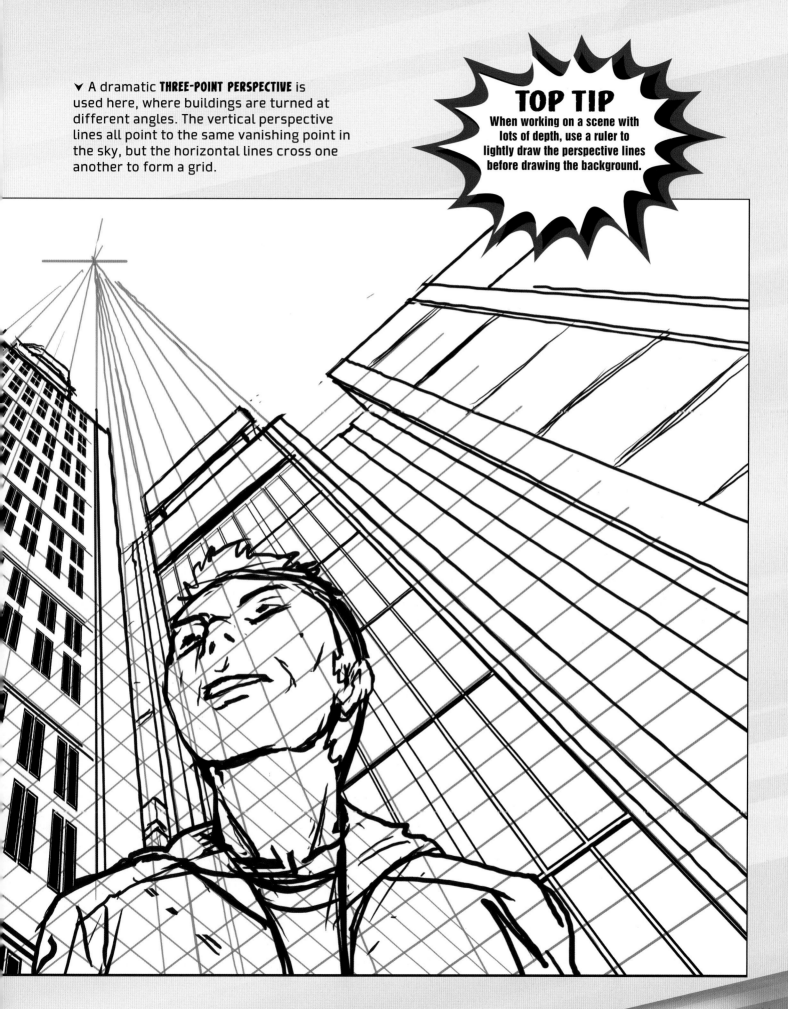

▼ A dramatic **THREE-POINT PERSPECTIVE** is used here, where buildings are turned at different angles. The vertical perspective lines all point to the same vanishing point in the sky, but the horizontal lines cross one another to form a grid.

TOP TIP
When working on a scene with lots of depth, use a ruler to lightly draw the perspective lines before drawing the background.

HERO HQ

Home, sweet home! Now that you've seen how to create an exciting exterior, it's time to turn your attention to your heroes' headquarters. Enter the Loft, base for the Knight Patrol.

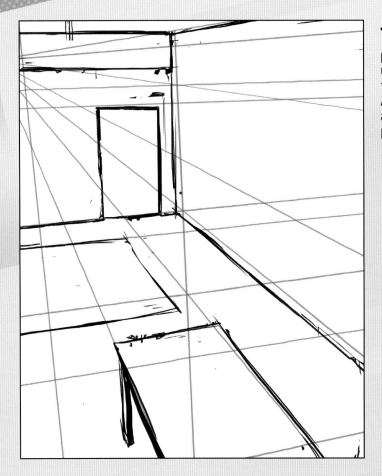

1. As with the street, perspective lines are used to work out angles for the floor and walls. A table in the room also follows the same perspective.

NAME: NOCTURNA

REAL IDENTITY: Alice Long

POWERS: Able to disappear into shadows and teleport between areas of darkness.

ORIGIN: Inherited the mystical Twilight Gem from her father, the Shadow Boxer.

STRENGTH	◆◇◇◇◇
INTELLIGENCE	◆◆◇◇◇
SPECIAL POWERS	◆◆◆◇◇
FIGHTING SKILLS	◆◇◇◇◇

2. Chairs and other furniture can be placed in the scene. Compare the size of the chairs with the door on the far wall. Perspective makes the chairs look bigger in relation to the background features. Some extra decor, such as the weapon racks and lamps, is added to the apartment to suit its owner—the hero, Caracal.

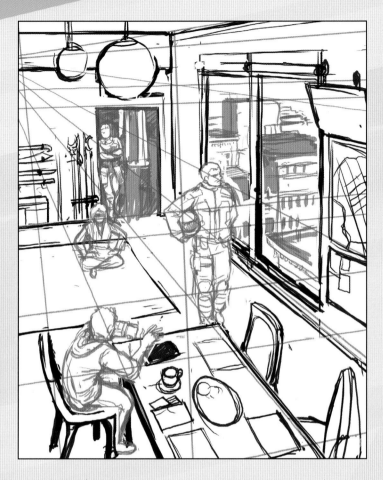

3. Now that the room is planned, the heroes can be positioned. Use perspective lines to help you draw the heroes at their correct relative sizes. Nocturna, the woman dressed all in black, is the tallest member of the Knight Patrol. Stealth and Blind Justice are seated. Blind Justice doesn't like chairs!

NAME: CARACAL

REAL IDENTITY: Josiah Ward

POWERS: Retractable claws in gloves and boots, for climbing and combat.

ORIGIN: After years on the wrong side of the law, former mercenary Ward chose to return to the streets of his birth and lead a war against crime.

STRENGTH ◇◇◇◇◇◇
INTELLIGENCE ◇◇◇◇◇◇
SPECIAL POWERS ◇◇◇◇◇◇
FIGHTING SKILLS ◇◇◇◇◇◇

4. Each member of the Knight Patrol interacts with the setting and the other characters. Consider what your characters are doing in each scene. Here, Caracal is looking out of the window while Stealth is drinking coffee and checking his computer watch.

TOP TIP
So that your characters inhabit a convincing 3D world, it is often better to place them in a room rather than draw an environment around them.

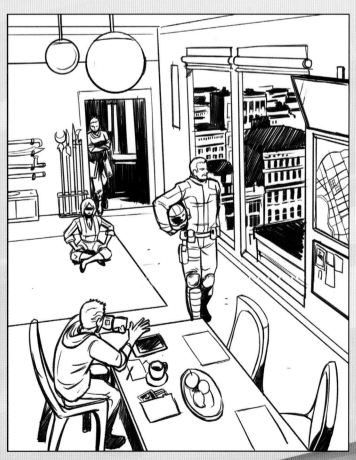

SPEAK OUT!

So far, your urban heroes have been the strong and silent types. With some well-chosen words, you can make the action and words leap off the page.

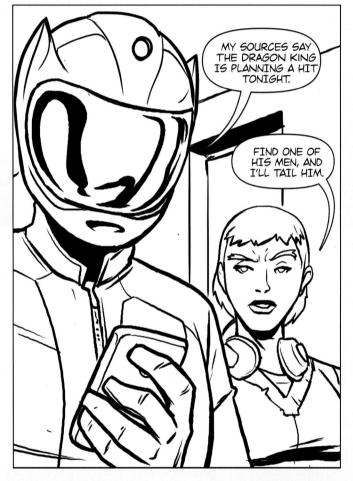

⌃ Comic books use speech balloons to hold dialogue. Though you can vary the shapes, balloons tend to be oval, with a tail from the balloon pointing toward, but not touching, the mouth of the speaker. Words are usually in capital letters.

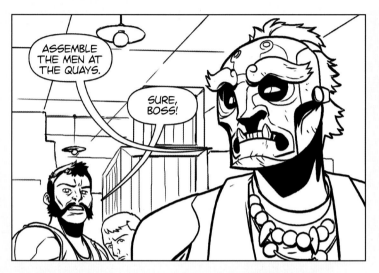

⌃ Spoken words, such as the action on the page, should be read from top left to bottom right, so think ahead when you place your characters in a panel. Don't have their speech balloons crossing! Above is an example of what NOT to do.

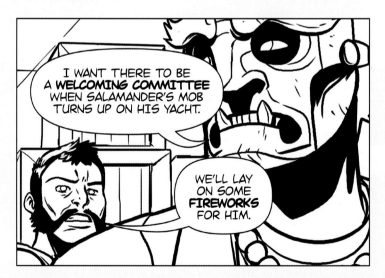

⌃ Be sure to allow enough room for the talking. Try not to cover up the characters with speech balloons!

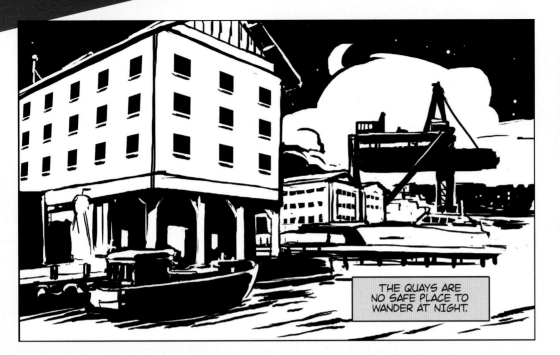

NAME: THE DRAGON KING

REAL IDENTITY: Unknown

POWERS: Gangland boss who can hypnotize people with his ferocious mask.

ORIGIN: After a series of mysterious deaths of mob bosses, the Dragon King stepped forward to fill the void and rule Capital City's underworld.

STRENGTH ◆◆◆◇◇
INTELLIGENCE ◆◆◆◆◇
SPECIAL POWERS ◆◇◇◇◇
FIGHTING SKILLS ◆◆◆◇◇

THE QUAYS ARE NO SAFE PLACE TO WANDER AT NIGHT.

▲ You can add a caption in a box to set a scene.

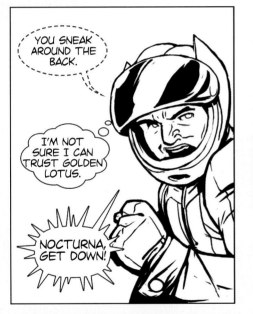

YOU SNEAK AROUND THE BACK.

I'M NOT SURE I CAN TRUST GOLDEN LOTUS.

NOCTURNA, GET DOWN!

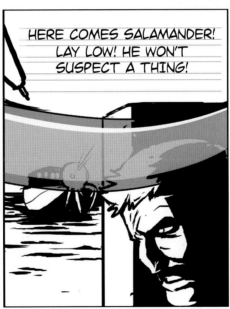

HERE COMES SALAMANDER! LAY LOW! HE WON'T SUSPECT A THING!

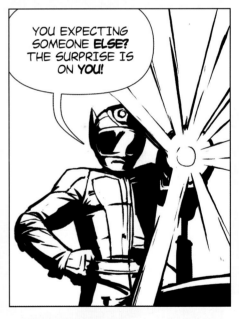

YOU EXPECTING SOMEONE **ELSE?** THE SURPRISE IS ON **YOU!**

▲ Speech balloons can be different shapes for different expressions:

· A dashed border for whispers.

· A cloud shape for thoughts.

· A starburst for shouts or screams.

▲ When writing speech, use lightly ruled lines with some space between them. Write in the dialogue, then use an ellipse template or curve tool, if you have one, to draw the balloon borders.

▲ Write in neat capitals and leave a border around the words inside the balloon. A technical pen is good for this. You can use a thicker pen to write bolder words for emphasis.

Finally, remember that comics are a visual medium. While words matter, don't forget to show your characters expressing themselves with their actions, too!

POINT OF VIEW

If you want to add extra dynamism to your comic book story, you need to choose some exciting viewpoints.

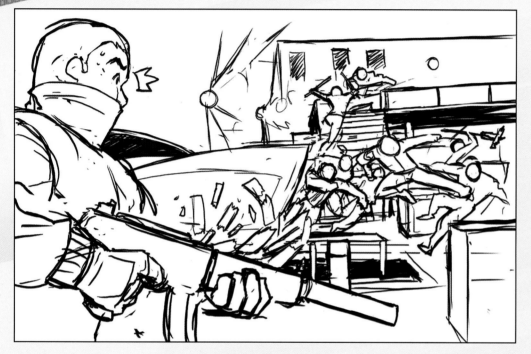

◄ The viewpoint is similar to a camera position in a movie. For the big quayside showdown between the Knight Patrol and the Lurker's mob, we need to choose a good viewpoint where we can see all the important action.

This first attempt is low angle, from the dockside, as the boat crashes into the quay. This is what the gangsters see from their viewpoint, but in it the Knight Patrol is too distant.

➤ This **BIRD'S-EYE VIEW** is more interesting, but we still feel too far from the action.

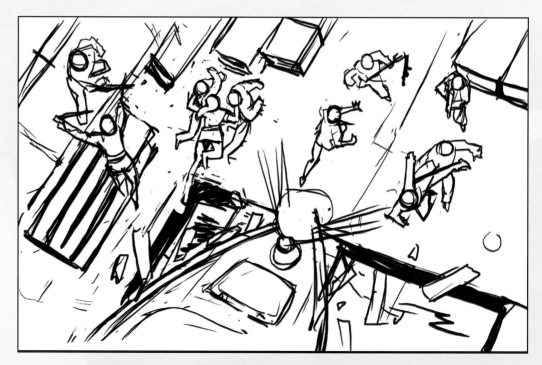

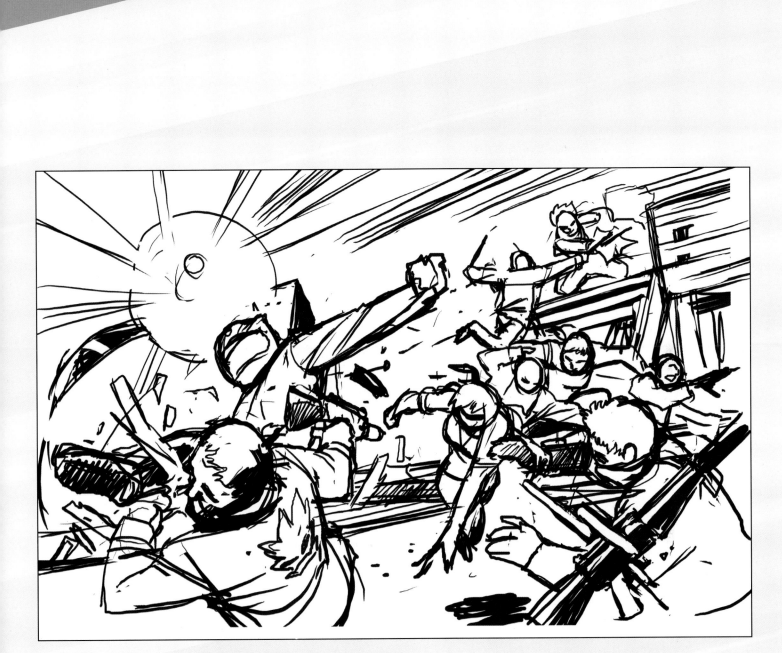

▲ This is better! We're right in the middle of the action here, as the Knight Patrol makes easy work of the Lurker and his mobsters. You can almost feel Caracal's kick making contact, and the viewpoint allows you to be led around the scene.

TOP TIP
A dramatic point of view looks great in one panel, but if you choose too many different views on one page, it can make the reader feel dizzy!

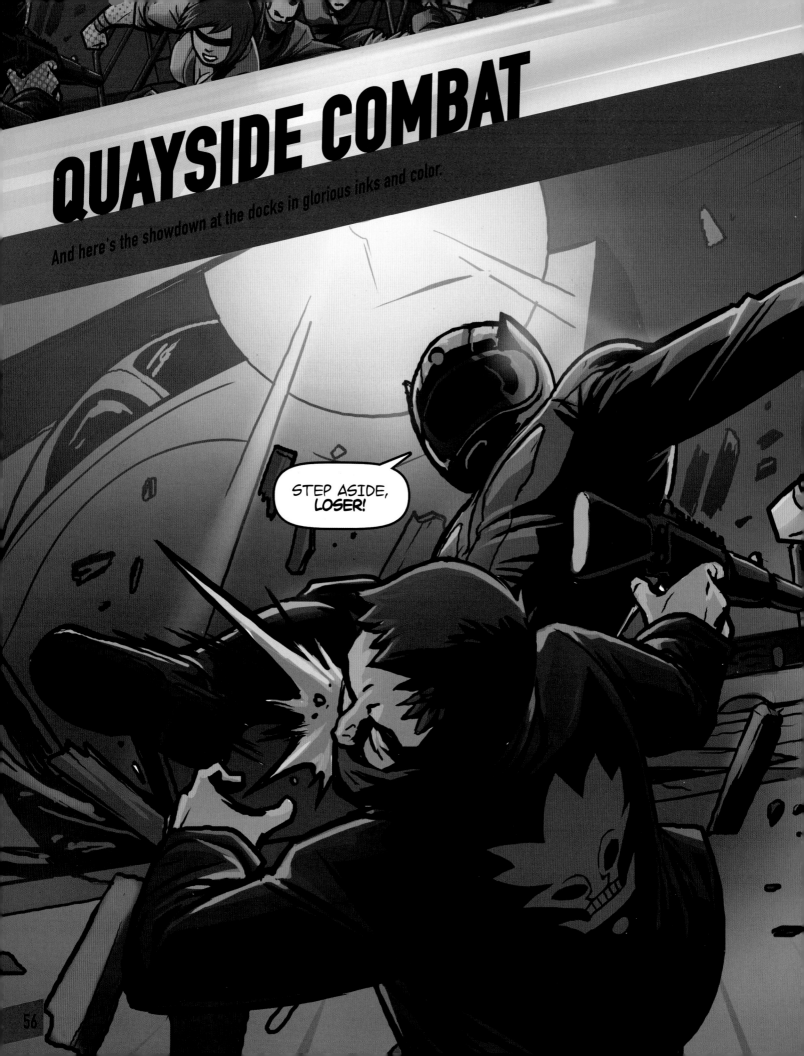

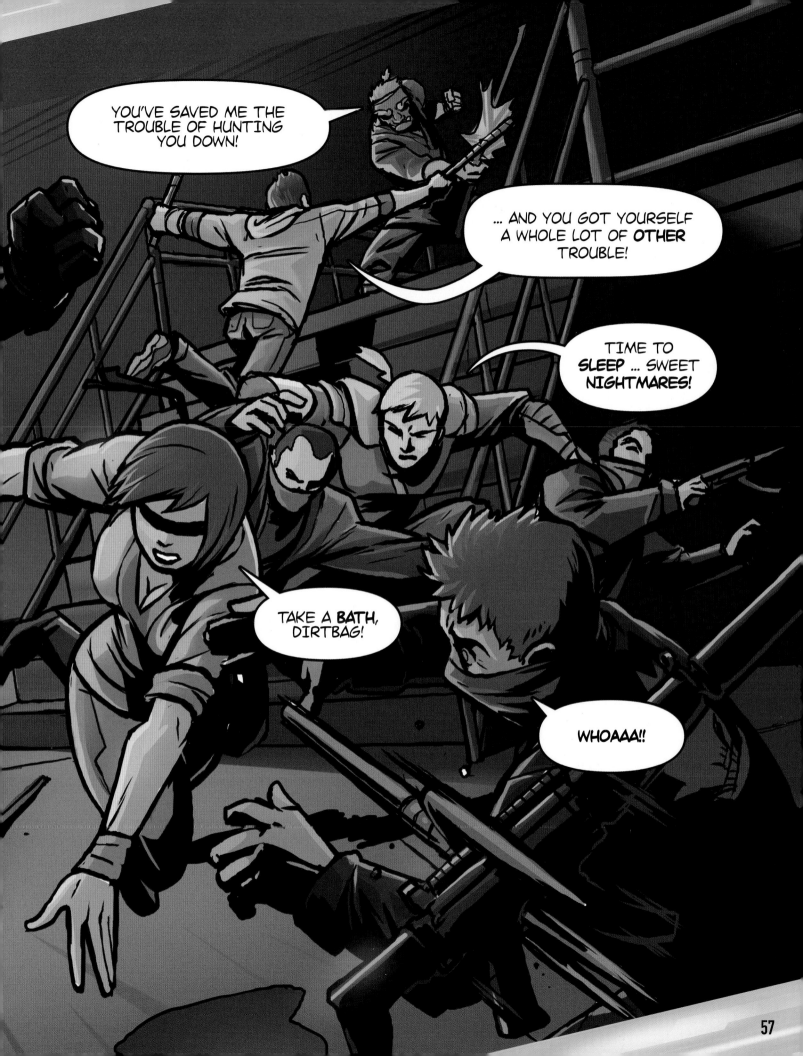

STEAL THE SPOTLIGHT!

Conversations in comics aren't just about speaking and listening. With the right choice of panels, you can plan your dialogue scenes for maximum visual impact.

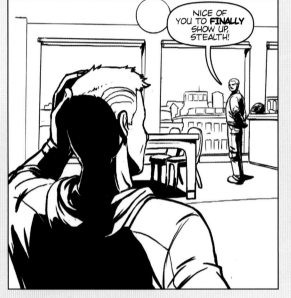

When planning your comic book story, you need to choose which moments you want to show—to keep the story going—and how much you need to reveal in a panel.

The left-hand panel sets the exterior scene, but the right-hand panel is better, with both characters seen inside their HQ.

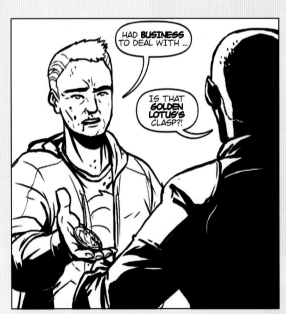

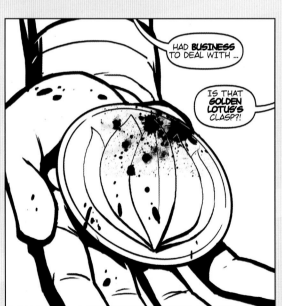

Stealth has brought something of importance to show Caracal, but you can't see it clearly in the left-hand panel. The close-up in the right-hand panel draws attention to the object—a blood-splashed clasp! Shock!

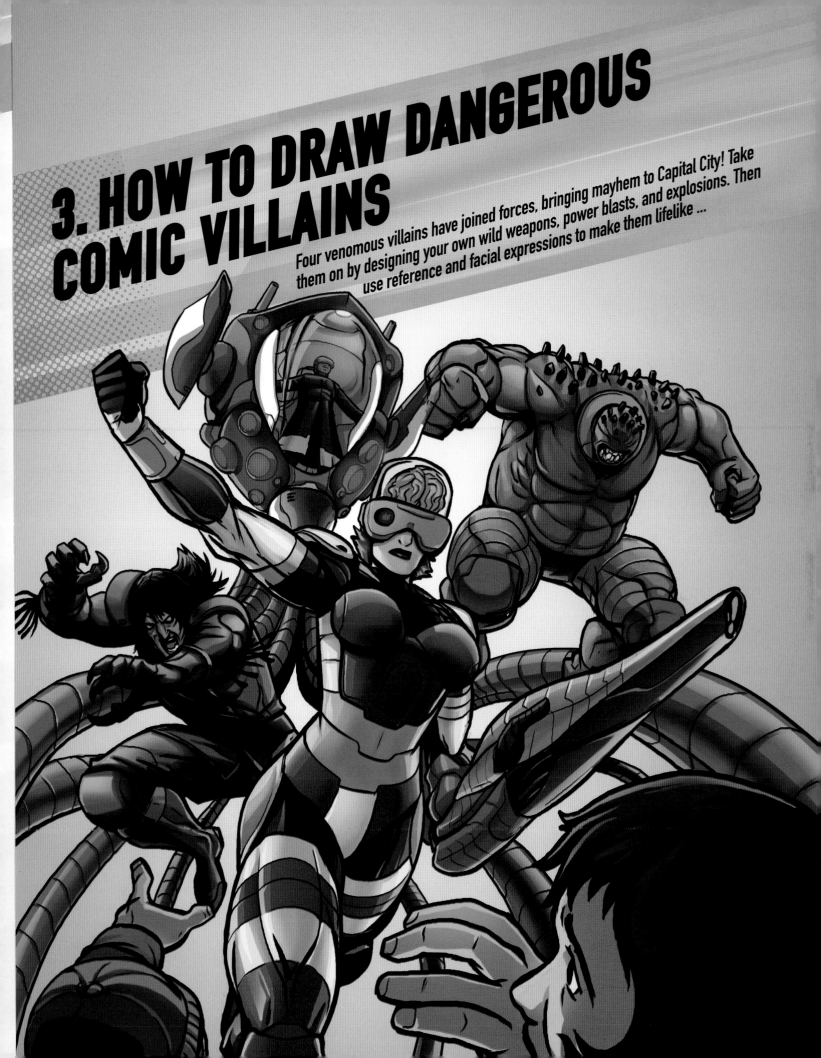

3. HOW TO DRAW DANGEROUS COMIC VILLAINS

Four venomous villains have joined forces, bringing mayhem to Capital City! Take them on by designing your own wild weapons, power blasts, and explosions. Then use reference and facial expressions to make them lifelike ...

EVIL OPPOSITE

If you're trying to come up with a villain to take on a hero, imagine what their opposite would be.
Evil cyborg Upgrade could be the mirror image of a hero who uses technology for good—or even of a hero who has beneficial powers over nature.

MOTIVATION

What drives your villain? Upgrade's lack of emotion is what makes her a monster, not her weapons. By cutting off her feelings, she doesn't think about the harm she may cause others. Equally, it is hard to persuade her to stop being a villain.

NAME: UPGRADE

REAL IDENTITY: Paola Barzetti

POWERS: Strong and fast bionic body incorporating blaster weapons.

ORIGIN: Convinced that artificial intelligence would one day rule Earth, Barzetti detached her pain receptors and replaced her human parts with weapon tech.

STRENGTH ◆◆◆◆◇
INTELLIGENCE ◆◆◆◇◇
SPECIAL POWERS ◆◆◆◆◇
FIGHTING SKILLS ◆◆◆◇◇

3. HOW TO DRAW DANGEROUS COMIC VILLAINS

Four venomous villains have joined forces, bringing mayhem to Capital City! Take them on by designing your own wild weapons, power blasts, and explosions. Then use reference and facial expressions to make them lifelike ...

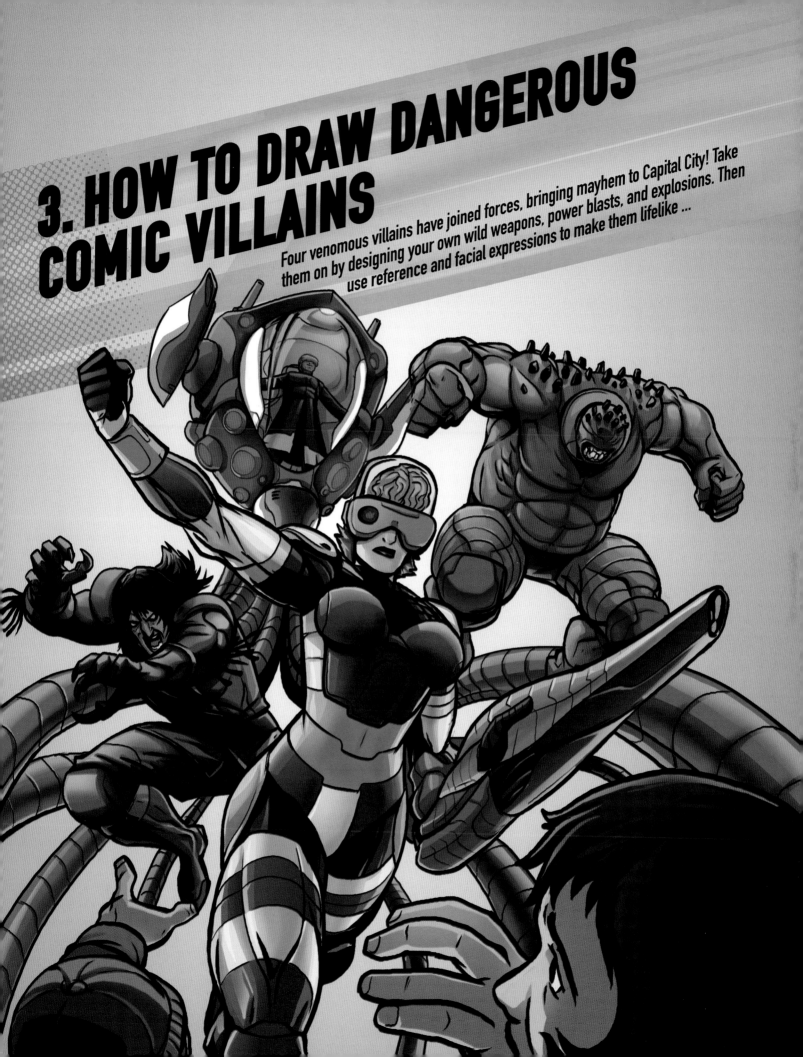

VILE VILLAINS

Super villains are a lot of fun to create. They can look mean and scary, and carry all kinds of wild-looking weapons. Here are some tips on how to create memorable villains—then let them loose to cause trouble!

BAD BRAINS

You can't go wrong with a mad scientist—they come up with the wildest world-conquering schemes, and their inventions can take your stories in fun and unexpected directions. Let your imagination run wild! While this professor may not look particularly strong, he has all the best gadgets.

NAME: PROFESSOR PAYNE

REAL IDENTITY: Parzival Payne

POWERS: Ultra-intelligent inventor.

ORIGIN: Payne's only friend as a child was his computer. His obsessive studies led him to become a scientific genius with no compassion for people.

STRENGTH ◆◇◇◇◇
INTELLIGENCE ◆◆◆◆◆
SPECIAL POWERS ◆◆◆◆◇
FIGHTING SKILLS ◆◇◇◇◇

SCHEMER

A super-villain team is usually led by the biggest brain, rather than the strongest fighter—someone who can come up with the cleverest ways of defeating heroes and bringing power or wealth to their evil chums. Your villain's greatest power might be how they control other people.

CREEPY COLORS

Killgore has chosen a typically villainous color scheme for his costume—green and purple. Reds, blues, and yellows just seem too bright and positive for a villain.

POSTURE

Note this mutant's menacing pose. Even if you only saw his shadow, you'd know he was creepy! While heroes tend to stand tall and proud, villains like Killgore often skulk, hunch, or pose in a threatening way.

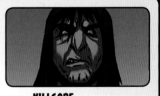

NAME: **KILLGORE**

REAL IDENTITY: **Gordon Kiehl**

POWERS: Has claws that can cut through rock and metal.

ORIGIN: Insane rock star Kiehl remixed his own DNA live on stage and grew unbreakable talons. Impossible to imprison, Killgore breaks the law just for the publicity.

STRENGTH ◆◆◆◇◇
INTELLIGENCE ◆◆◇◇◇
SPECIAL POWERS ◆◆◇◇◇
FIGHTING SKILLS ◆◆◆◆◇

EVIL OPPOSITE

If you're trying to come up with a villain to take on a hero, imagine what their opposite would be.
Evil cyborg Upgrade could be the mirror image of a hero who uses technology for good—or even of a hero who has beneficial powers over nature.

MOTIVATION

What drives your villain? Upgrade's lack of emotion is what makes her a monster, not her weapons. By cutting off her feelings, she doesn't think about the harm she may cause others. Equally, it is hard to persuade her to stop being a villain.

NAME: UPGRADE

REAL IDENTITY: Paola Barzetti

POWERS: Strong and fast bionic body incorporating blaster weapons.

ORIGIN: Convinced that artificial intelligence would one day rule Earth, Barzetti detached her pain receptors and replaced her human parts with weapon tech.

STRENGTH	◈◈◈◈◇
INTELLIGENCE	◈◈◈◇◇
SPECIAL POWERS	◈◈◈◈◇
FIGHTING SKILLS	◈◈◈◇◇

ACHILLES HEEL

An Achilles heel is a character's weak spot that can be exploited and lead to his downfall. In the case of Brutus, the more he pushes himself to be stronger, the less intelligent he becomes. For heroes to outwit him, they need to find him weak and clever—or they must push the strong version to make a stupid mistake.

NAME: BRUTUS

REAL IDENTITY: Bruce Tuska

POWERS: The stronger he gets, the dumber he becomes.

ORIGIN: Scientist Tuska, testing a super-strength formula on himself, gained massive power at the expense of his intelligence.

STRENGTH	◆◆◆◆◆
INTELLIGENCE	◆◇◇◇◇
SPECIAL POWERS	◆◆◇◇◇
FIGHTING SKILLS	◆◆◇◇◇

MUSCLE-BOUND

Brutus is super-strong but still needs realistic anatomy. Although you can exaggerate the muscles in a human body, you need to know where they go and what they do. Then it's time to smash!

FEEL THE POWER

The Gauntlet is ready to strike with his symbiotic glove's devastating power bolts. Here's how to draw the bad guy from scratch and fire up his deadly weapon.

NAME: THE GAUNTLET

REAL IDENTITY: Evgeny Blok

POWERS: Wears an alien glove that fires plasma blasts and affects gravity.

ORIGIN: Blok discovered his glove weapon in the wreck of an alien spaceship in Siberia and became possessed by its twisted alien consciousness.

STRENGTH ◆◆◇◇◇
INTELLIGENCE ◆◆◇◇◇
SPECIAL POWERS ◆◆◆◆◇
FIGHTING SKILLS ◆◇◇◇◇

1. WIREFRAME

Start with a simple figure to show the pose of your villain and the direction in which his head is turned. The Gauntlet is all about his power glove, so his right hand is raised to show it off.

2. BLOCK FIGURE

Fill out the Gauntlet's figure using 3D shapes. Not every character needs to be tall and muscular. Blok is a heavy-set character—he found his weapon by accident and doesn't need to be lean or athletic to use it.

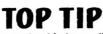
TOP TIP
The contrast between the
Gauntlet's army-surplus clothing
and his symbiotic glove works
well here. Who is in charge—
the man or the alien?

3. ANATOMY

Now work on the villain's anatomy, defining
his chest, belly, arm, and leg muscles. You
can start to add detail to his alien power
glove, too.

4. FINISHED PENCIL SKETCHES

Now the Gauntlet gets his costume. It hangs
loose around his padding and boots. Give your
villain a mean, unfriendly expression, and add
a flare ahead of the glove as it fires.

HAVING A BLAST!

Power bolts can be drawn in many ways. Here are just a few.

You can have a starburst effect, with rays shooting from an explosive source.

You can have a cosmic power bolt that starts with a splash before becoming thinner and controlled.

Or you can have a mini electrical storm, with a lightning bolt surrounded by electrical charges.

5. INKS

Using ink with a pen or brush, carefully go over the pencil lines you want to keep. The Gauntlet's cap casts a shadow, but his eyes glow bright in the dark to show he is possessed by the glove!

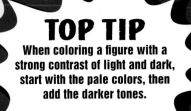

6. COLORS

Time for color! The blast from the glove lights the Gauntlet's costume. The other side of his outfit is in shadow. The contrast of light and dark adds drama to the figure and makes the glove appear even more fearsome.

TOP TIP

When coloring a figure with a strong contrast of light and dark, start with the pale colors, then add the darker tones.

WATCH OUT!

Fugitive X means serious business! Follow the steps to draw this super-strong villain lifting up a boulder, ready to hurl it toward a hero.

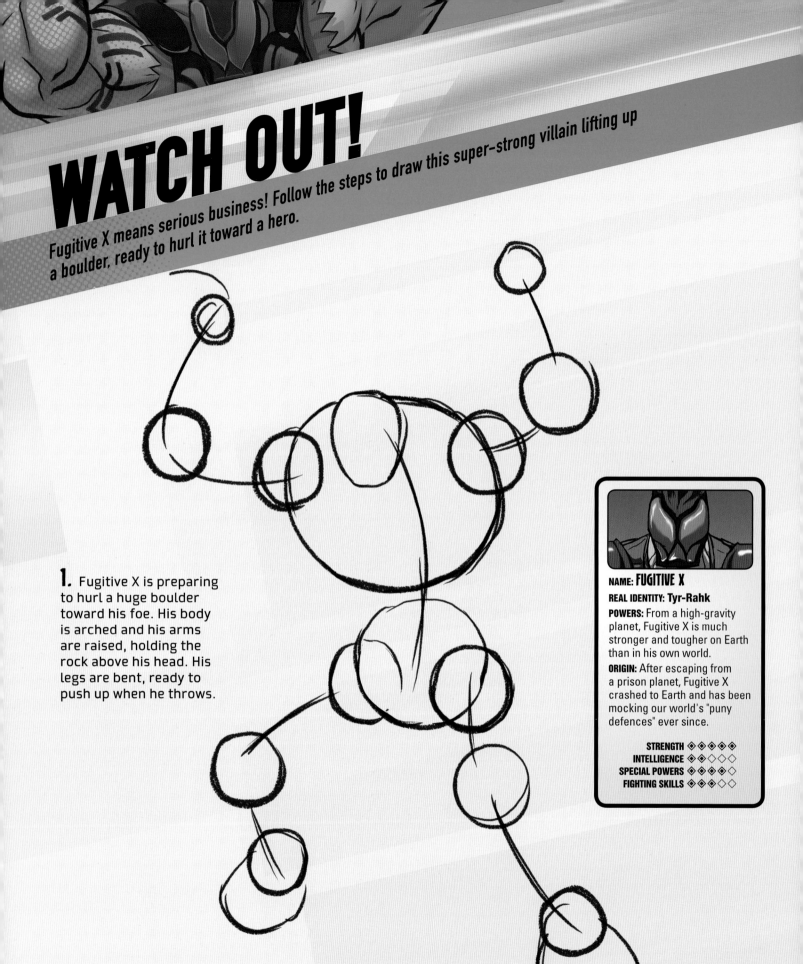

1. Fugitive X is preparing to hurl a huge boulder toward his foe. His body is arched and his arms are raised, holding the rock above his head. His legs are bent, ready to push up when he throws.

NAME: FUGITIVE X

REAL IDENTITY: Tyr-Rahk

POWERS: From a high-gravity planet, Fugitive X is much stronger and tougher on Earth than in his own world.

ORIGIN: After escaping from a prison planet, Fugitive X crashed to Earth and has been mocking our world's "puny defences" ever since.

STRENGTH ◇◇◇◇◇
INTELLIGENCE ◇◇◇◇◇
SPECIAL POWERS ◇◇◇◇◇
FIGHTING SKILLS ◇◇◇◇◇

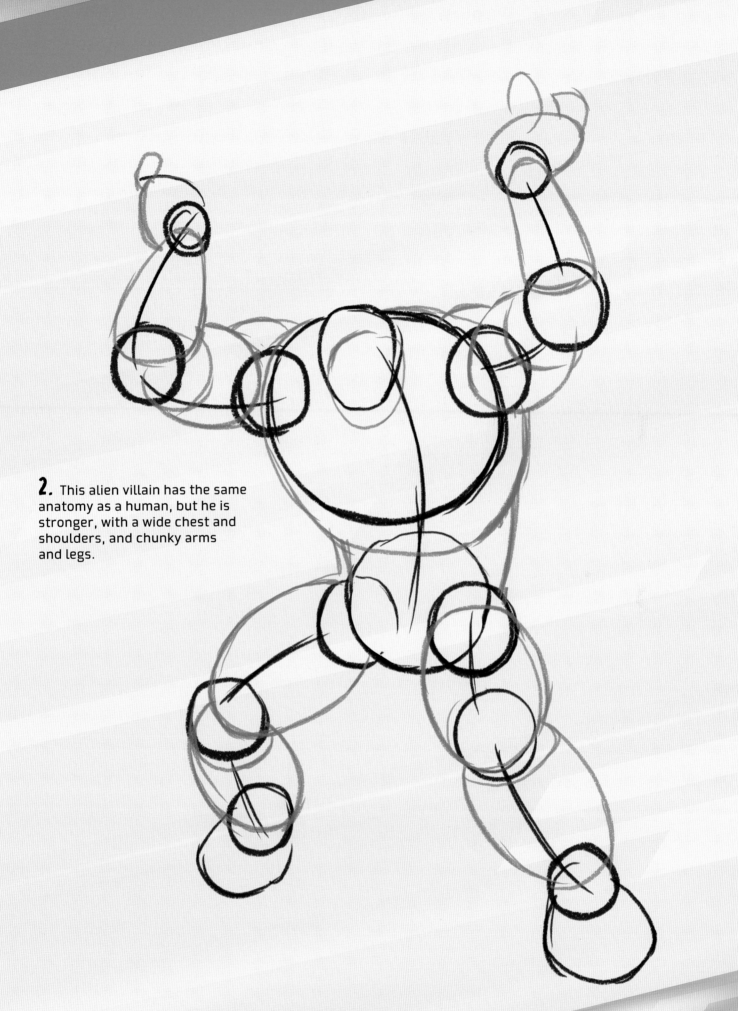

2. This alien villain has the same anatomy as a human, but he is stronger, with a wide chest and shoulders, and chunky arms and legs.

3. The muscles in Fugitive X's lower arms and thighs are bulging as he supports the weight of the large rock. His padded clothing mimics the muscles underneath. Alien prison tattoos have been added to his arms.

4. In the finished color art, texture has been added to the boulder to make it look rocky. Most of Fugitive X is in shade below it. The dark hues add to his menace.

WEIGHTY WORK

To hold such a heavy weight above his head, Fugitive X needs to balance himself. His **CENTER OF GRAVITY** is shown by a vertical line drawn through a point just behind his belly button to the ground between his feet. For the figure to look balanced, the weight of the rock and his body should be evenly distributed on each side of the line.

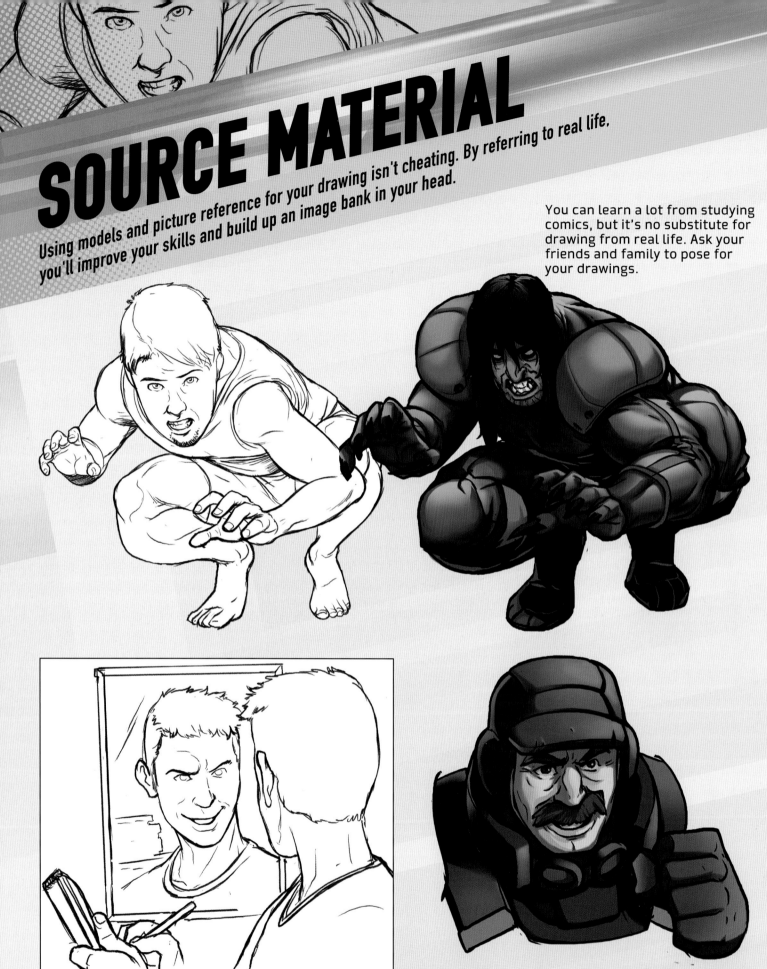

SOURCE MATERIAL

Using models and picture reference for your drawing isn't cheating. By referring to real life, you'll improve your skills and build up an image bank in your head.

You can learn a lot from studying comics, but it's no substitute for drawing from real life. Ask your friends and family to pose for your drawings.

A mirror is a must! Use yourself as a model to capture tricky facial expressions, hand gestures, and poses.

Keep clippings of useful magazine photos of athletes, fashion, vehicles, and buildings, or search online for reference pictures. But, although using picture references can improve the realism in your drawing, don't let it stop you from using your imagination!

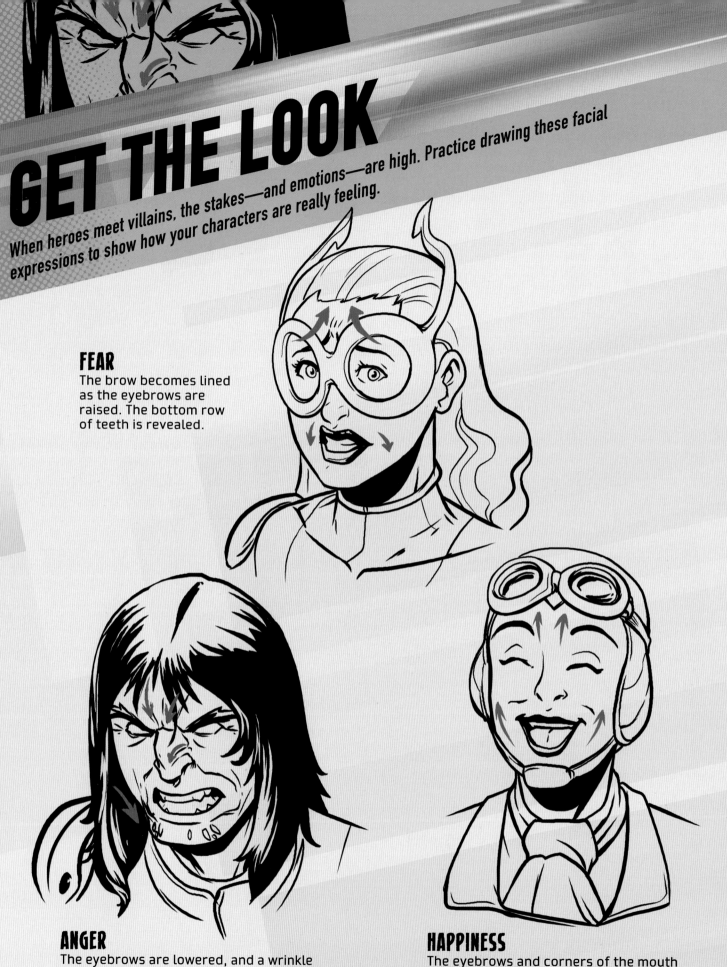

GET THE LOOK

When heroes meet villains, the stakes—and emotions—are high. Practice drawing these facial expressions to show how your characters are really feeling.

FEAR
The brow becomes lined as the eyebrows are raised. The bottom row of teeth is revealed.

ANGER
The eyebrows are lowered, and a wrinkle appears above the nose. Teeth are gritted.

HAPPINESS
The eyebrows and corners of the mouth are raised, creating creases at the sides. The cheeks are pushed up.

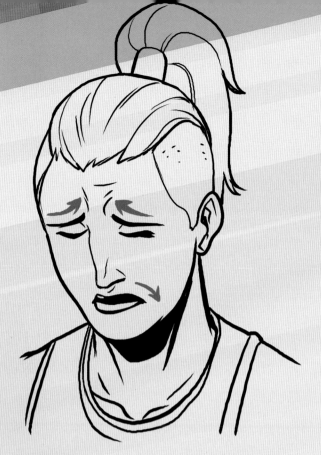

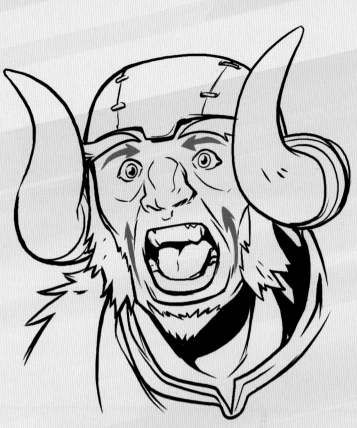

SADNESS
The eyes look down. The bottom lip sticks out, and the brow is wrinkled.

SHOCK
The mouth and eyes are wide open, with the eyebrows raised.

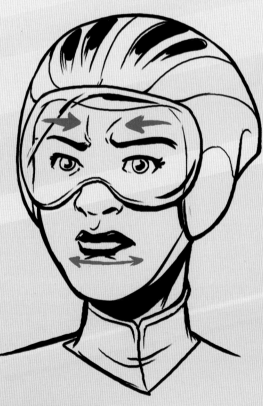

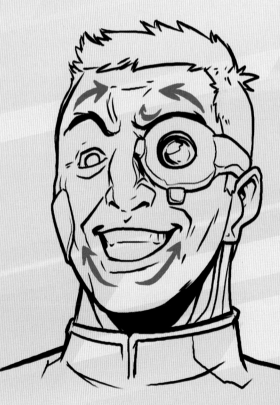

DETERMINATION
The eyebrows are lowered in a straight line. Eyes look straight ahead, with the mouth closed tightly.

MANIA
A wide toothy grin, the eyes looking forward, with one raised eyebrow and wrinkles above.

SMASH IT UP!

The Terror Trio—Igniter, Trauma, and Aftershock—are ripping up the streets! Here's how you can cause destruction, too ... but only on paper, please!

1. To start a fire, lightly pencil parallel rows of zigzags, including peaks of different heights.

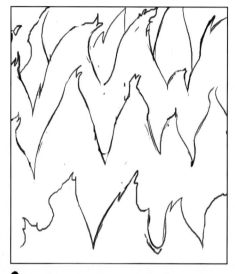

2. Use these lines as guides for drawing curved, irregular flames.

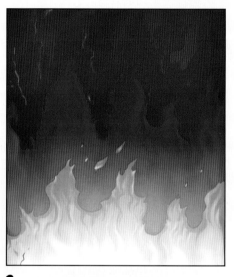

3. Color the flames from white at the base, to yellow, through orange, to red at the top.

1. For an explosion, lightly pencil curves moving outward from the center of the blast.

2. Connect some of these curves to form a darker cloud around the blast center. Add a few shoots of flame leaping from the fireball.

3. Color the explosion with a dark red outer layer, turning to paler reds and yellows inside, with flashes of white where the blast is hottest.

76

1. For earthquakes, lightly pencil zigzags to show where the ground is breaking. Divide the ground around these lines into irregular shapes, like jigsaw pieces.

2. Now draw a rocky edge on each broken piece of ground to show that it has been raised. Choose different edges and angles for each piece.

3. For the finished destruction, rough and rocky texture has been added to the broken pieces of ground, with more cracks and a few stones jumping into the air.

NAME: IGNITER

REAL IDENTITY: Roisin Byrne

POWERS: Able to turn a spark into raging flames.

ORIGIN: As a youth, Byrne got into trouble for causing fires. Later, she discovered she was a mutant with power over plasma.

STRENGTH ◇◇◇◇◇◇
INTELLIGENCE ◇◇◇◇◇◇
SPECIAL POWERS ◇◇◇◇◇◇
FIGHTING SKILLS ◇◇◇◇◇◇

NAME: TRAUMA

REAL IDENTITY: Spike Tucker

POWERS: Hurls balls of energy that cause explosions where they hit.

ORIGIN: Surviving a quantum bomb blast, Tucker absorbed its energy and became able to transmit it as small explosions.

STRENGTH ◇◇◇◇◇◇
INTELLIGENCE ◇◇◇◇◇◇
SPECIAL POWERS ◇◇◇◇◇◇
FIGHTING SKILLS ◇◇◇◇◇◇

NAME: AFTERSHOCK

REAL IDENTITY: Dr. Zane Lennox

POWERS: Causes violent tremors through touch when angry.

ORIGIN: Temperamental, disgraced scientist Lennox developed a costume that converts his rages into an earthquake-creating force.

STRENGTH ◇◇◇◇◇◇
INTELLIGENCE ◇◇◇◇◇◇
SPECIAL POWERS ◇◇◇◇◇◇
FIGHTING SKILLS ◇◇◇◇◇◇

DEADLY DEVICES

Super villains are always coming up with new dangerous weapons, from blasters to heavy-duty tanks. Get to grips with the art of menacing machinery.

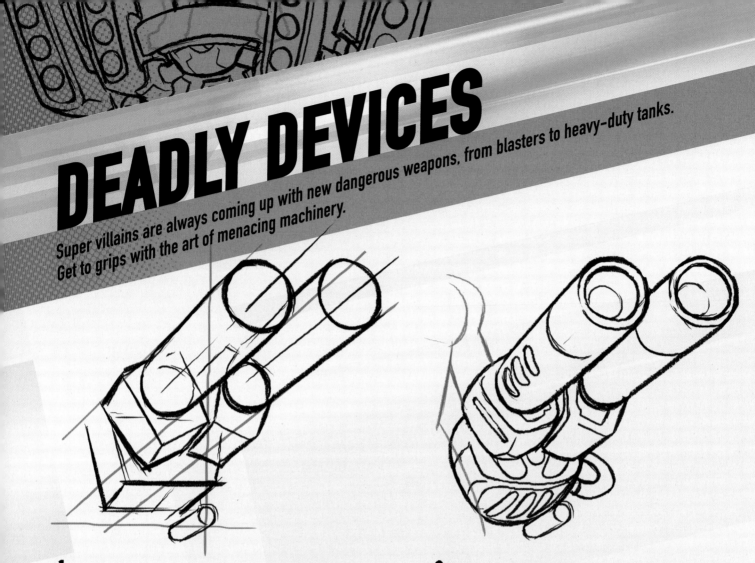

1. Upgrade's double-barreled atomic disruptor is based around two cylinders. Pencil these, using **PERSPECTIVE LINES** as a guide, then add other 3D shapes to build up the device.

2. The finished pencil sketches have smoothed the corners of the 3D shapes and include a power cable, lights, and vents.

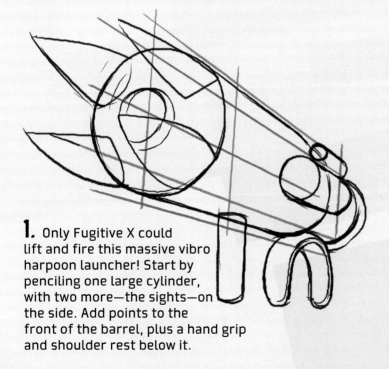

1. Only Fugitive X could lift and fire this massive vibro harpoon launcher! Start by penciling one large cylinder, with two more—the sights—on the side. Add points to the front of the barrel, plus a hand grip and shoulder rest below it.

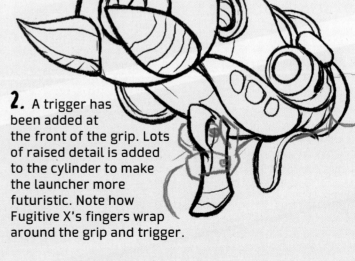

2. A trigger has been added at the front of the grip. Lots of raised detail is added to the cylinder to make the launcher more futuristic. Note how Fugitive X's fingers wrap around the grip and trigger.

1. Professor Payne has his own personal attack platform, armed to the teeth with blasters and rocket launchers. First sketch the base for Payne to stand on, with a raised front and steering column. Add rectangular fins and blocks for the weapons on each side.

2. In the pencil sketches, the 3D shapes and platform front are more curved. Each blaster array is aimed forward, with a heat vent at the rear. Consider how the mad professor will fit on his attack platform.

Now turn the page to see how these weapons are used in the final scene.

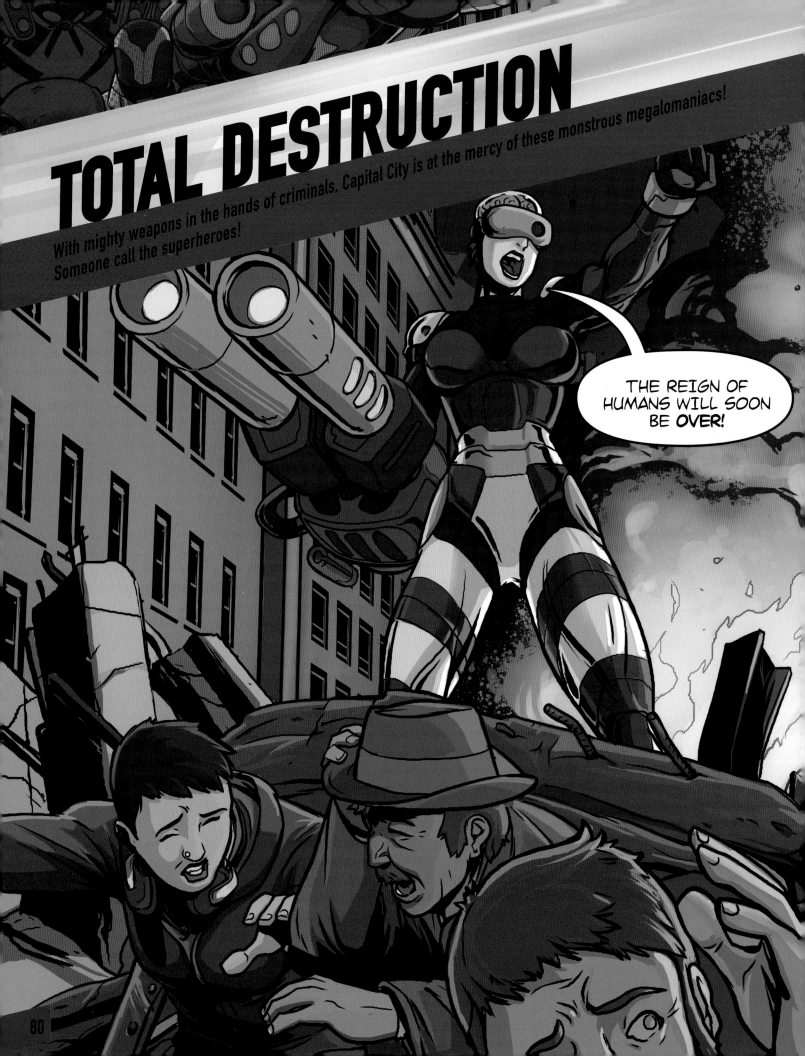

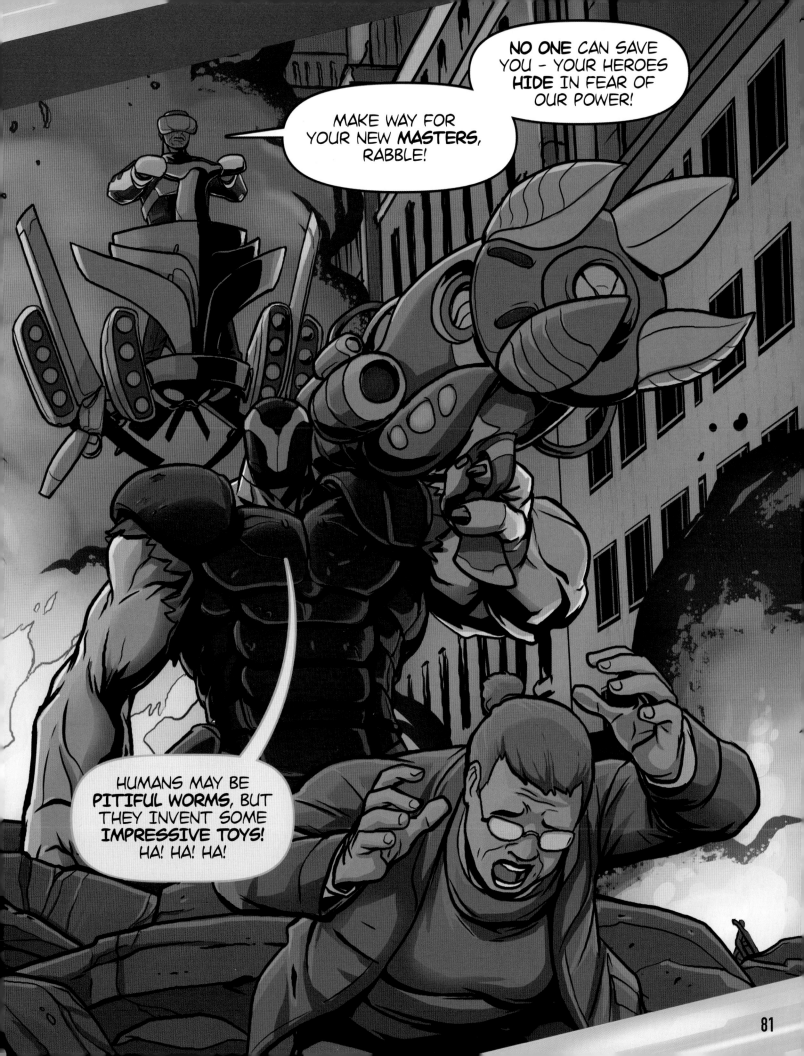

81

HANDS UP!

A successful villain may rub his hands in glee, point, punch, or brandish a weapon. Hands can seem hard to draw at first—here are some simple steps for getting to grips with them.

OPEN HAND

Start by drawing a round-edged square for the palm. Radiating from this, add lines following each finger and thumb bone. Check the finger lengths against your own hand. Draw circles for the joints, then an outline around these to form the shape of the fingers and thumb. Add lines on the palm and one or two wrinkles on each finger and thumb joint.

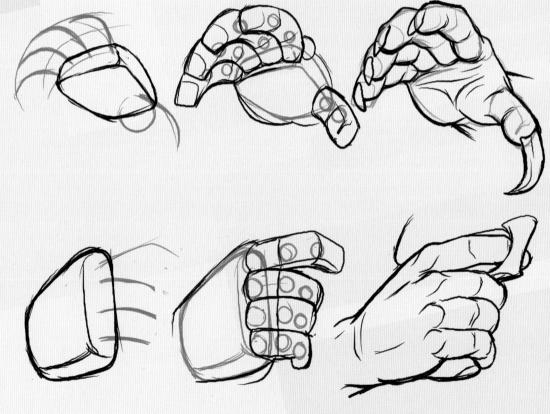

CLAW

Start by drawing the palm as a flat box, with four curved lines for the fingers and one hooked thumb. Add circles for the finger and thumb joints Now draw the outlines for all the fingers and thumbs around these, adding sharp fingernails at the end.

GRIPPING BACK OF HAND

Start by drawing the back of the hand as a small, flat box. Add lines showing the position of the gripping fingers, plus circles for the knuckles. Now draw the outlines for all the fingers, with wrinkles on the joints.

4. HOW TO DRAW COSMIC COMIC HEROES

Warrior aliens are invading Earth space. Can the Outriders, a rogue band of space heroes, stop them? Help save our solar system by creating cool cosmic characters and designing awesome aliens, robots, spaceships, and fantastic worlds ...

SPACE SQUADRON

Originating from different worlds, our quartet of galactic heroes are very different in personality, shape, style, and color. Here are some pointers to use when creating your own comic characters.

TAKING CHARGE

When creating a leader for a team, don't always go for the obvious choice. Captor is the strongest warrior in the Outriders, but he is a loner. Star Runner is a tough, experienced soldier and by far the best strategist, who will look out for all her teammates.

NAME: STAR RUNNER

REAL IDENTITY: Glory Keyes

POWERS: Space pilot and engineer.

ORIGIN: After disobeying orders to save her team, Captain Keyes was drummed out of the Space Corps and formed her own platoon for hire.

STRENGTH ◆◇◇◇◇
INTELLIGENCE ◆◆◆◆◇
SPECIAL POWERS ◆◆◇◇◇
FIGHTING SKILLS ◆◆◆◇◇

ENVIRO-SUIT

Consider your characters' needs in outer space. As a human, Star Runner needs a spacesuit to survive the rigors of cold, airless space. Her suit is based on an early twenty-first-century design but is leaner due to advances in space wear since interstellar travel became possible.

GADGETS

Design some cool hardware and clothing for your space travelers. Fzzik does not need a spacesuit, but wears a device that projects a force field around his body. This also protects him from laser fire. The communications device by his mouth translates his alien language. Without it, all his teammates hear is a clicking sound.

NAME: FZZIK

REAL IDENTITY: Fzzik

POWERS: A natural chameleon with the ability to adapt to new environments and change his appearance.

ORIGIN: Fzzik was orphaned during a battle on his home planet Zephr 2 and rescued by Star Runner. Though only two Earth years old, Fzzik is an adult in Zephran terms.

STRENGTH	◆◆◆◇◇
INTELLIGENCE	◆◆◇◇◇
SPECIAL POWERS	◆◆◆◇◇
FIGHTING SKILLS	◆◆◇◇◇

STRANGE ANATOMY

Alien characters give you the freedom to break anatomy rules, though it may help to base your alien forms on human or animal bodies, even mixing them up. While Fzzik walks on two legs like a human, he is somewhat insectlike, with four double-jointed arms. Lilac fur adds another alien touch.

GEAR CHANGE

Robot bodies are built up from simple geometric shapes. Proto has a basic human form but with metal parts. Whoever designed him loved the old tech of cogs, rods, and gears, but new pirate tech has been added to his systems to make this math android more useful in battle. The two technologies are contrasting.

NAME: PROTO

REAL IDENTITY: Pro-T-0

POWERS: Familiar with all types of alien tech and weapons; fires laser beams from eyes; excellent accountancy skills.

ORIGIN: This mathematical android designed by Sol Stocks Inc. was stolen during a heist, and upgraded and reprogramed by pirates.

STRENGTH	◇◇◇◇◇
INTELLIGENCE	◇◇◇◇◇
SPECIAL POWERS	◇◇◇◇◇
FIGHTING SKILLS	◇◇◇◇◇

PURPOSE BUILT

When building machinery, including robots, think about the purpose of each part. The cables along Proto's limbs are hydraulic and give him movement. He is powered by solar energy cells on his shoulders. The cogs inside his chest are his central processing unit or brain.

RELOCATION

What culture do your alien characters come from? Captor is a galactic tough-guy whose red-colored skin reflects his fiery heritage. He has a wild attitude and background similar to that of Earth's Viking warriors. Imagine how other societies from Earth's past might develop in a new or hostile environment on another planet. How would they be different?

NEW WORLDS, NEW WEAPONS

This alien warrior wears armor and carries various exotic weapons. While he is happy to use advanced blaster weapons, the blades he carries suggest he prefers hand-to-hand combat. Try to give your cosmic characters clothes and weapons with an alien twist. Invent new fashions and weapons for new aliens who have never visited Earth.

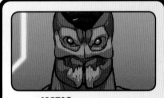

NAME: CAPTOR
REAL IDENTITY: Grail Tor
POWERS: Fierce fighter, excellent tracker.
ORIGIN: Galactic bounty hunter Tor was framed for treason he didn't commit. Adopting a new identity, Captor, he now hunts space criminals as part of the Outriders.

STRENGTH ◇◇◇◇◇◇
INTELLIGENCE ◇◇◇◇◇◇
SPECIAL POWERS ◇◇◇◇◇◇
FIGHTING SKILLS ◇◇◇◇◇◇

STELLAR GUARD

The cloned peacekeeper Star Sentinel patrols our galaxy guided by his robot companion, Valis. Bring him to life, so that he can use his stellar scepter to prevent interplanetary war.

NAME: STAR SENTINEL

REAL IDENTITY: Gazon An Talik

POWERS: Can cross the galaxy in an instant by creating wormholes. His scepter fires gravity waves.

ORIGIN: One of hundreds of clones created by the Space/Time Directorate, Gazon is tasked with brokering peace across the Milky Way.

STRENGTH ◇◇◇◇◇
INTELLIGENCE ◇◇◇◇◇
SPECIAL POWERS ◇◇◇◇◇
FIGHTING SKILLS ◇◇◇◇◇

1. WIREFRAME

Draw a simple, jointed stick figure to show the pose of your hero soaring through space. His right hand holds his scepter of power and reaches toward the reader. Indicate his robot companion with a circle.

2. BLOCK FIGURE

Bulk out Star Sentinel's body with 3D shapes. As the scepter pulls him toward you, his left hand appears as large as his head, and his body gets thinner toward his toes. This effect is called **FORESHORTENING**.

3. ANATOMY

Star Sentinel has an alien face but similar anatomy to a human. Start giving definition to his muscles. Note that his head is pushed back as he looks forward, while his lower body is turned at a slight angle.

4. FINISHED PENCIL SKETCHES

You can now add the details of the protective space uniform over Star Sentinel's body, including his jacket, belt, padding, and clear helmet. Draw the grid pattern on his costume last, curving the lines around his body.

COMPUTER COMPANION

I'M GETTING REPORTS OF **BORDER INCURSIONS** ON POPL-5.

Star Sentinel has a robot companion, Valis, to give him reports, directions, and to open miniature wormholes to transport the pair of them across the galaxy in an instant.

Having another character to talk to helps when it comes to writing a story for the hero. Valis can give Star Sentinel instructions and even make jokes with the hero. Without Valis, Star Sentinel will have to talk to himself ... or it will be a very quiet comic!

5. INKS

Carefully ink the lines you want to keep, using a brush or pen. You may want to use a fine-line pen to draw the grid and patterns on his uniform, to keep the lines a regular thickness, and to complete any technical details on the scepter and robot.

6. COLORS

Star Sentinel wears a uniform rather than a superhero costume. It looks more official than a soldier's uniform. He is permitted to use force if peace negotiations fail. The colors and style of his suit match the design of his robot.

TOP TIP

Star Sentinel wears a mix of uniform and spacesuit. Try adding space tech or body armor to regular clothes for your own cosmic characters' clothing.

INSPIRED ALIENS

Meet the locals! If you need inspiration for how to fill the galaxy with amazing alien creatures, just look at the strange animals that live on Earth.

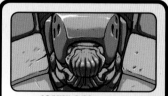

NAME: GRANIX DUR

REAL IDENTITY: Granix Dur

POWERS: Sharpshooting bounty hunter with an armored hide.

ORIGIN: Former bandit from the planet Termund; left home in search of greater gains.

STRENGTH	◇◆◆◆◇
INTELLIGENCE	◇◇◆◇◇
SPECIAL POWERS	◇◇◆◇◇
FIGHTING SKILLS	◇◆◆◆◇

▲ The giant armadillo is a South American mammal with flexible armored plating and long claws used for tearing through the earth for food.

➤ Imagine the armadillo walking on hind legs, with a bandolier across his chest and a warp blaster in his claw.

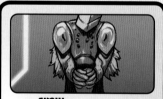

NAME: SKRIIL

REAL IDENTITY: Skriil

POWERS: This high-jumping insectoid serves overpriced fast food and juicy rumors.

ORIGIN: Skriil dreamed of joining his 427 brothers in the airborne Locust Legion, but after a failed medical, he could only get work as a chef on the galaxy's outer rim.

STRENGTH	◆◇◇◇◇
INTELLIGENCE	◆◇◆◇◇
SPECIAL POWERS	◆◇◇◇◇
FIGHTING SKILLS	◆◇◇◇◇

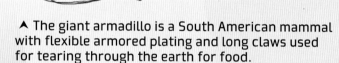

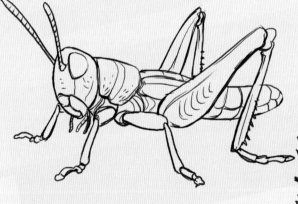

▲ The grasshopper is a vegetarian insect, with powerful back legs used for leaping between plants to escape danger.

➤ Enlarge the grasshopper to human size and give it thorny arms and legs; now it looks quite intimidating, even in a restaurant uniform!

The angle parentheses < > around the aliens' words mean that it is a translation from their language.

Dressed in clothing, the giant insect appears intelligent. It looks menacing but fragile.

Give the creature green skin, and it's an instant extraterrestrial! The bandoliers and armor suggest it's a survivor from an outlaw planet—not a creature you want to mess with!

TOP TIP
Don't be afraid of mixing and matching Earth creatures to design new aliens. How about crab claws on an ape or tentacles on a spider?

93

ROBOT RENDERING

Robots are commonplace in the worlds at the edge of our galaxy. Here are the nuts and bolts of constructing your own range of mechanical wonders.

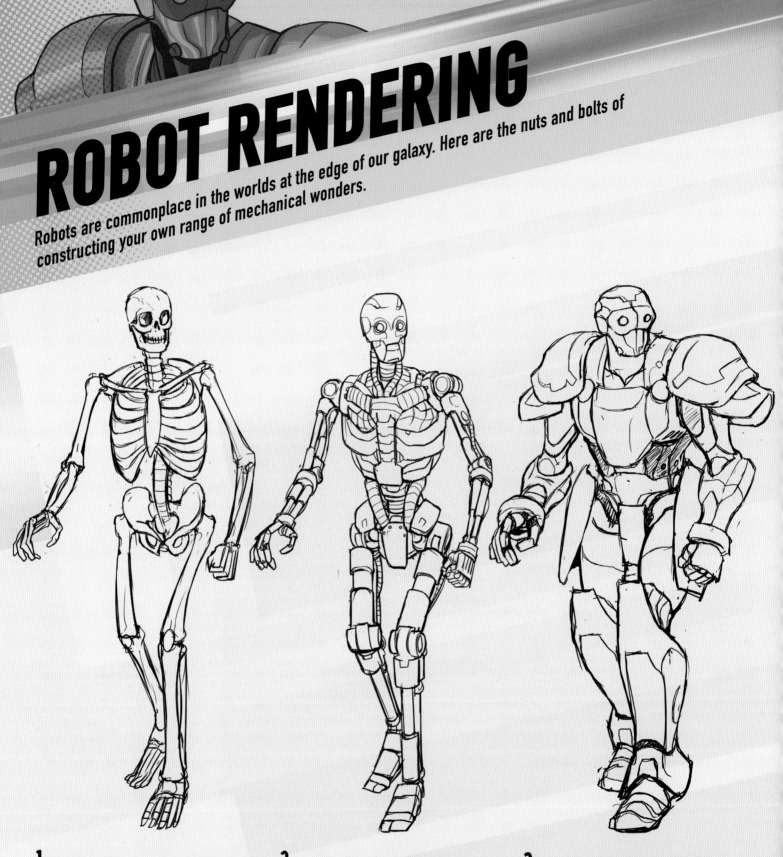

1. Androids are robots designed to mimic humans. This one is to be a service android, built for indoor tasks, not fighting. To construct it, first sketch a human skeleton.

2. Gradually replace the bones with more mechanical parts. Where the bones meet, place rivets and screws. Exaggerate body parts—expand the chest, while keeping the lower torso thin.

3. If you want your robot to be ready for action, cover some parts of the frame with molded metal plates. Add a power pack and light-up eyes to help your android function during day and night.

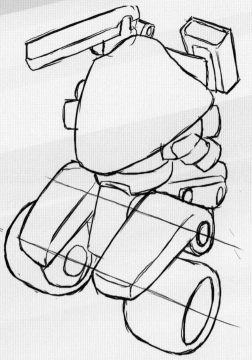

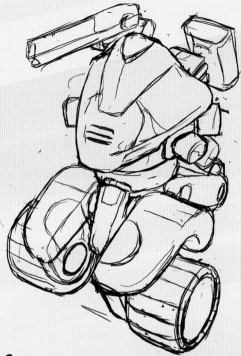

1. Robots can be any size and shape. This one runs on wheels and is built around a series of 3D shapes. It is a war robot, designed to be tough and deliver massive firepower.

2. More parts are added, and 3D shapes are given smoother outlines. The chunky tyres are designed for crossing extreme terrain. The machine has a sleek laser cannon mounted on one shoulder.

3. Lines are added to the bodywork to show how the frame is assembled. Vents have been added to the hood, and joints are placed between sections to show how the war robot can turn and raise weapons.

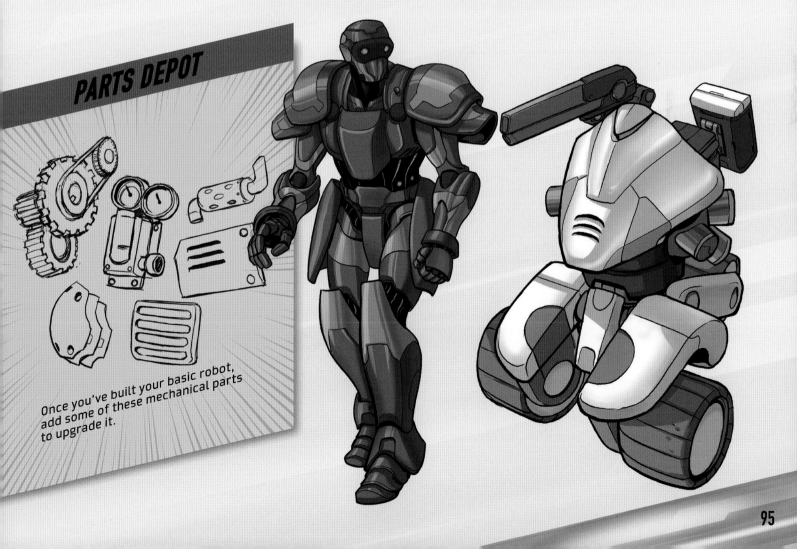

PARTS DEPOT

Once you've built your basic robot, add some of these mechanical parts to upgrade it.

LAUNCH BAY

Your cosmic heroes are going to need some transportation to get around. Here's how to design your own concept speedsters and spaceships, starting with real-life objects or simple shapes.

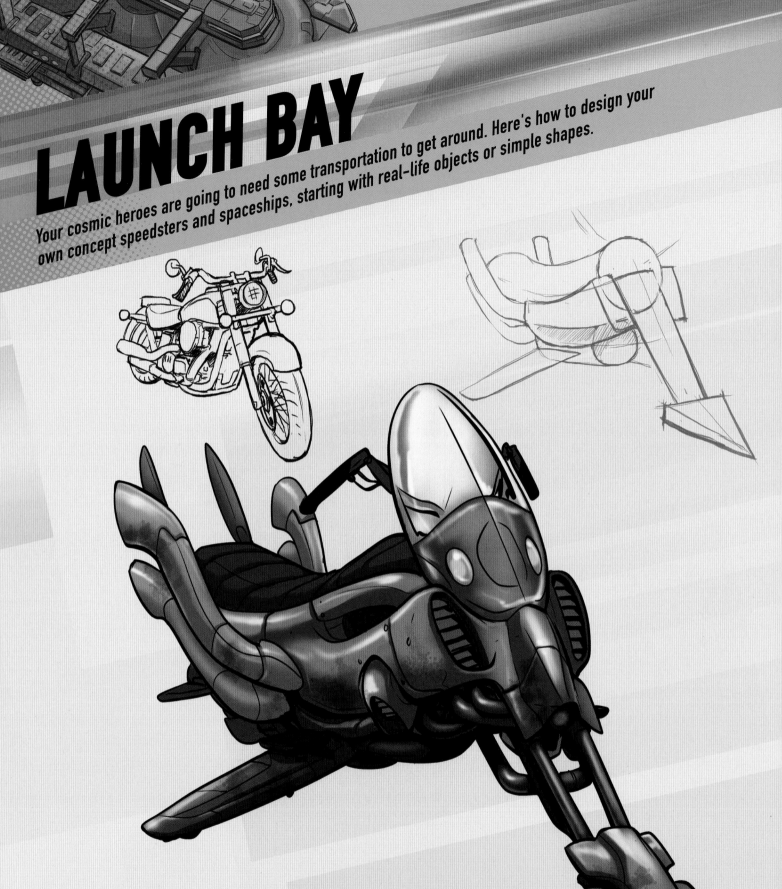

The BroncoTEC is a two-person hovering speedster used for jetting around the badlands of the planet Rachma, dodging mech rustlers. The design is based around a motorcycle chopper, with wings replacing wheels. Dust and grime on the vehicle show it is used in a hostile environment.

Consider how your alien vehicle is powered and what propulsion system it uses. The BroncoTEC is solar-powered and speeds along using rear jets and hover fans under the wings.

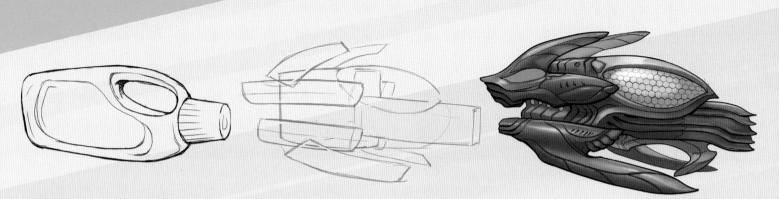

Inspiration for transportation can come from anywhere, not just existing vehicles. This Vespid fighter is based on a household detergent bottle! The cap has been extended to create a nose cone. The pilot sits inside the handle, and jagged fins sprout from the rear, surrounding its nuclear propulsion engine.

This Vespid is one of a squadron of fighters that are part of the United System of Gwalor's planetary defense corps. The cockpit has space for just one fighter pilot. The ship is armed with extending plasma cannons—one on each side—with two radion torpedos ready for launch from the nose cone.

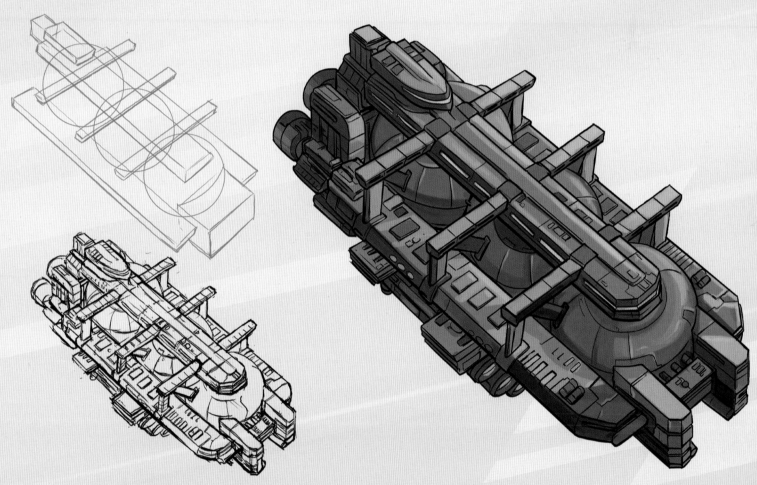

This space freighter doesn't have to have an aerodynamic shape. It is designed for long voyages and carrying large cargo—mainly metrinium from the mines of Kalso. It is built around a collection of 3D shapes—three large spheres for cargo—held together by a frame where the crew live and work.

There is nothing glamorous about this transportation vehicle. The body work is made up of thousands of metal plates. The windows and lights look tiny, which tells you how massive it is. It is too big to land on a planet. The crew leave it in orbit and use shuttles to visit other worlds.

GALAXY GUIDE

With a universe to explore, your characters will discover alien worlds very different to our own, with exotic plants and animals, plus unique, often hostile environments.

TOP TIP
Create a challenge for your cosmic heroes by sending them to worlds with high gravity, poisonous air, no sun, or extreme weather.

HOLD YOUR **NERVE**, TROOPERS! OUR SONIC RIFLES SHOULD DISRUPT THE VRADEX'S SENSES!

... ONLY IF WE HIT 'EM **FIRST**!

NAME: VRADEX

POWERS: Batlike aliens that can survive intense cold and find their way in the dark using sonar.

ORIGIN: Since the Ryassan Corporation began deep drilling on their planet, the Vradex's sonar has been affected. They are fighting to force the Ryassans out.

STRENGTH ◈◇◇◇◇
INTELLIGENCE ◈◇◇◇◇
SPECIAL POWERS ◈◈◇◇◇
FIGHTING SKILLS ◈◈◇◇◇

JUNGLE WAR

The Vradex are at war with the Ryassans. On the Vradex planet, the Ryassan troops need to wear enviro-suits. The soldiers are easy pickings for the Vradex warriors, who are used to these cold and shadowy conditions.

When you're inventing a planet, think about its position in space. Far away from a sun, the Vradex world is dark, with tangles of black vinelike plants that receive little light. The plants are watered by a creeping fog.

SCORCHED WORLD

Earth has many different environments—jungles, mountains, ice, oceans, and deserts that may inspire another world. By changing colors and including new plants and animals, you can transform a landscape.

Populate the sky with new moons, bizarre flying creatures, and futuristic airships, and a desert world becomes something much stranger. With the sun so large in the sky, this planet is extremely hot and dry. The locals have to look far and dig deep to find water.

STAR FIELD

In reality, the vacuum of space is largely empty. For a dramatic space setting, add rocky asteroids and gaseous clouds in the black void.

To add random groups of stars to your background, dip an old toothbrush in white paint, then flick your finger over the bristles to spray white specks over the black areas.

PLANET IN PERIL

Let's create a dramatic action scene set on an alien planet. The Absorbots are threatening to sap the life energy of the lush planet Phylla. Help the Outriders and Star Sentinel protect this world from annihilation.

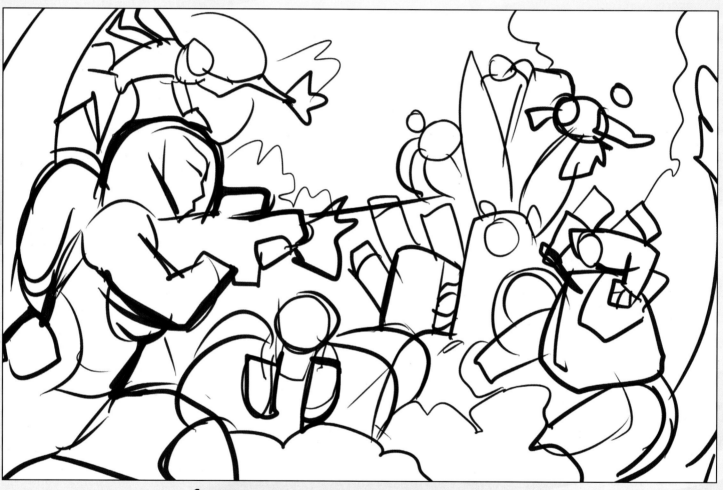

1. Roughly plan the position of your heroes and robotic villains in the alien scene. The Absorbots are defending their life-draining machine from attack. This is where the action is directed.

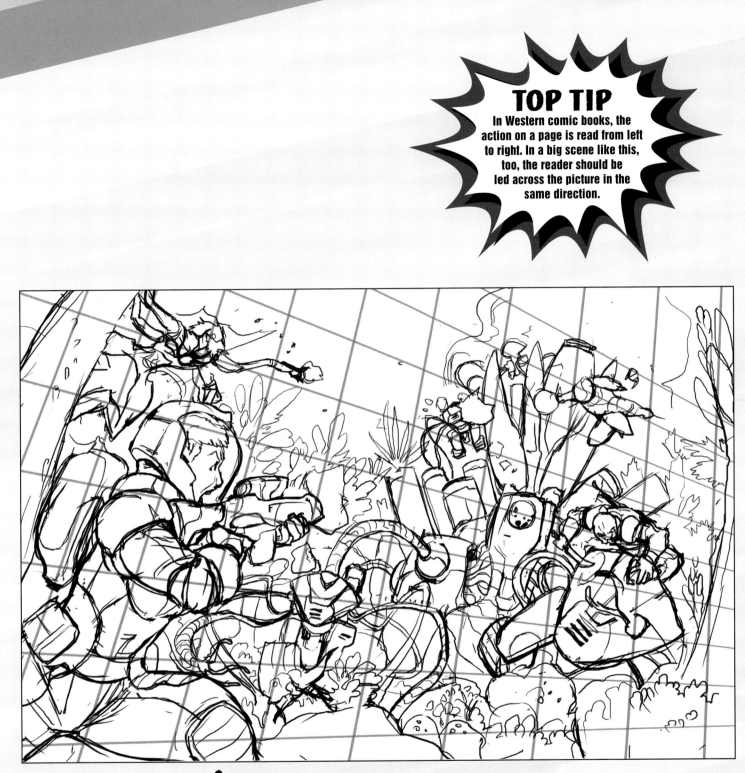

2. Build up the figures and machinery with 3D shapes. The grid of **PERSPECTIVE LINES** shows the direction of the action, led by Star Runner, on the left, moving toward the Absorbots' machine, on the right.

TOP TIP
Avoid placing all your characters in the same range, as it can make a scene feel flat. This picture works well because it has a lot of depth, with heroes up close and in the distance.

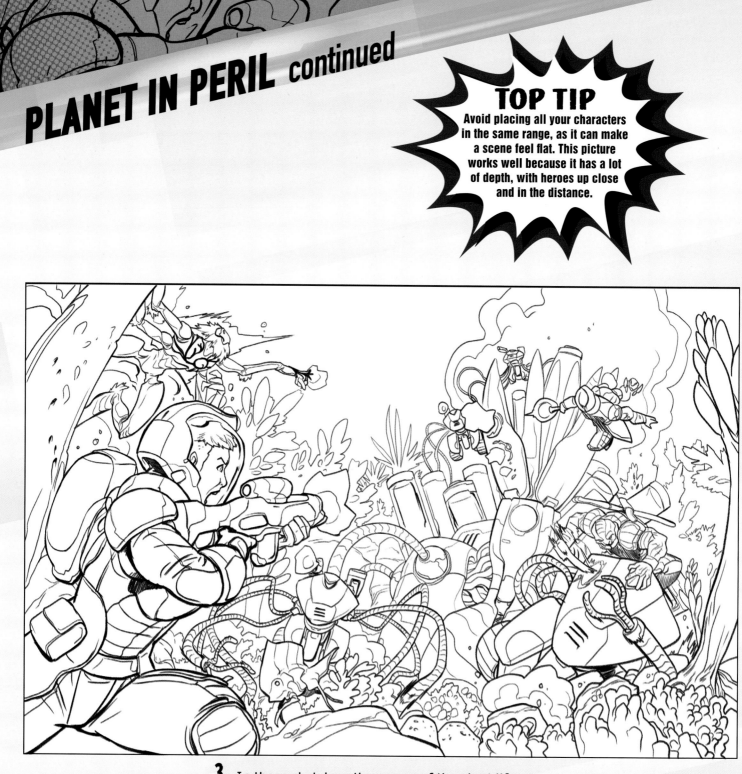

3. In these sketches, the curves of the plant life contrast with the blocky shapes of the Absorbots. The alien plants resemble an Earth coral reef, but are growing above ground.

NAME: ABSORBOTS

POWERS: Mechanical creatures that use animal and plant life as their power source.

ORIGIN: A cybernetic experiment gone wrong, the Absorbots learned to duplicate themselves, but can't produce their own power. They threaten all carbon-based life.

STRENGTH ◇◇◇◇◇
INTELLIGENCE ◇◇◇◇◇
SPECIAL POWERS ◇◇◇◇◇
FIGHTING SKILLS ◇◇◇◇◇

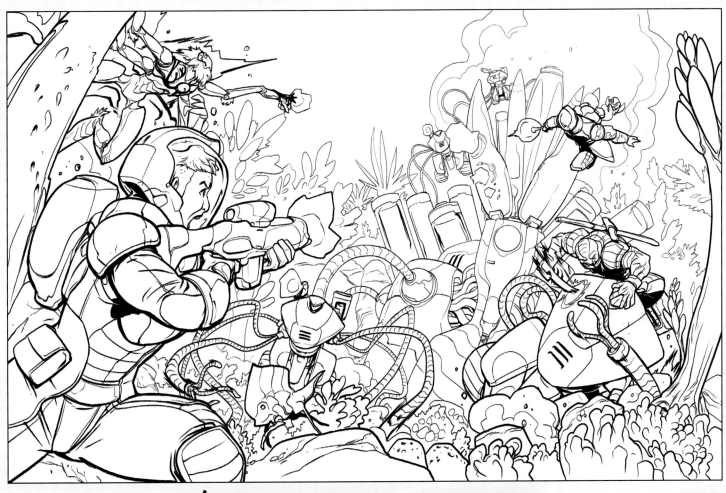

4. The finished scene is inked. Bolder outlines help the characters stand out from the background. There is a lot going on, but your eye should be led around the scene quite easily.

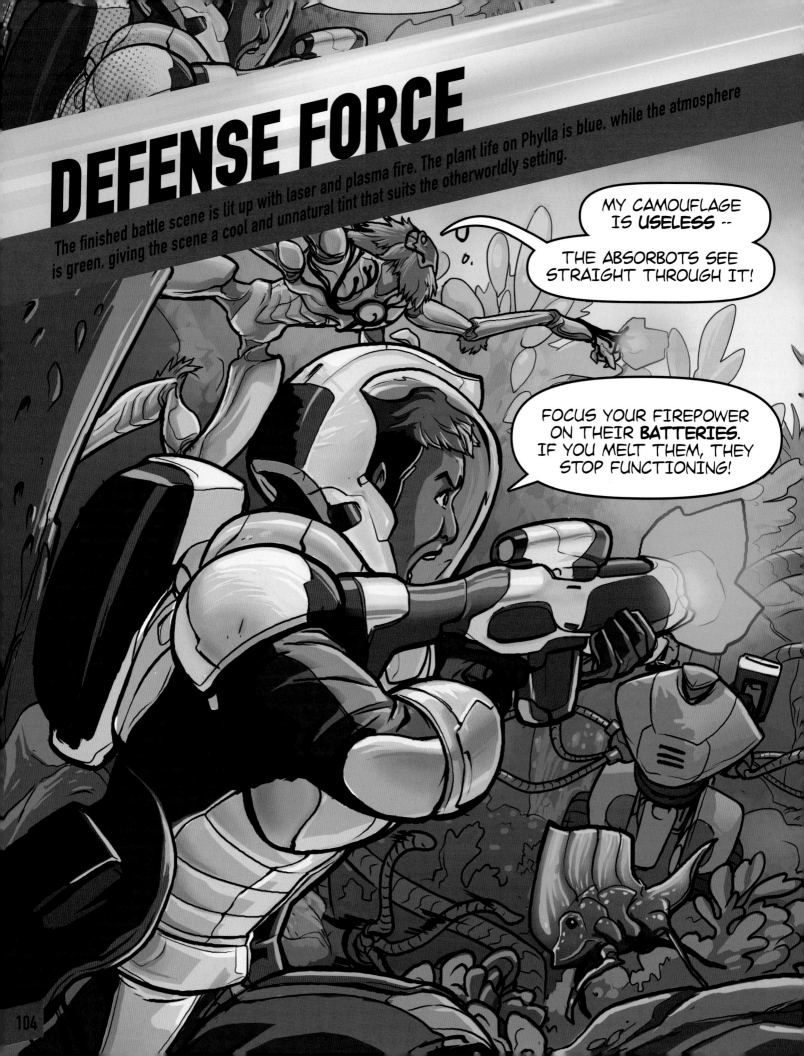

DEFENSE FORCE

The finished battle scene is lit up with laser and plasma fire. The plant life on Phylla is blue, while the atmosphere is green, giving the scene a cool and unnatural tint that suits the otherworldly setting.

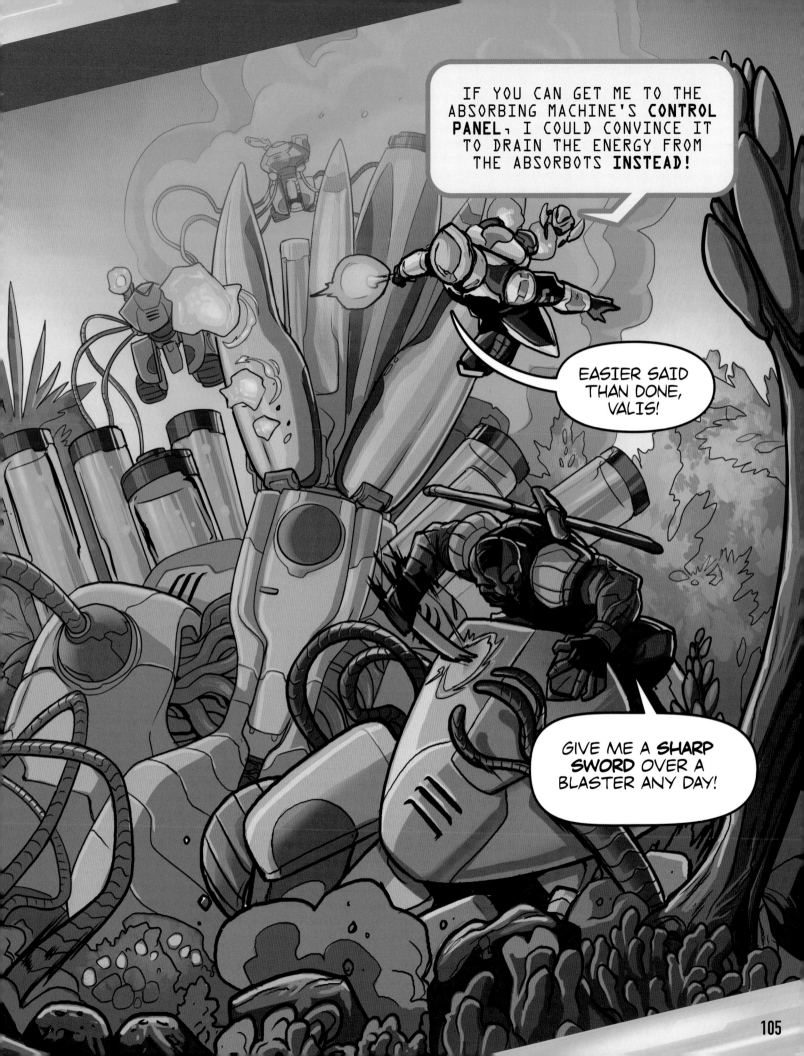

KEEP IT SNAPPY!

Can you make comic dialogue lively and fun? Different worlds and different cultures mean different opinions. Keep your comic characters distinct by giving them diverse personalities ... and add a little humor!

Not everyone talks the same. When you develop a new character, whether human or alien, give some thought to how they react to the world and other characters. Are they bossy, considerate, angry, or always cracking jokes?

It may help to imagine your hero or villain acting or talking like a character you've seen in a movie or animation, so you can imagine his voice in your head, talking in a distinct way. Here, Star Sentinel is heroic but innocent, while his robot Valis talks like a slightly patronizing adult.

In outer-space adventures, your characters are going to encounter lots of alien cultures and technology they don't understand. These encounters can lead to nail-biting or humorous scenes.

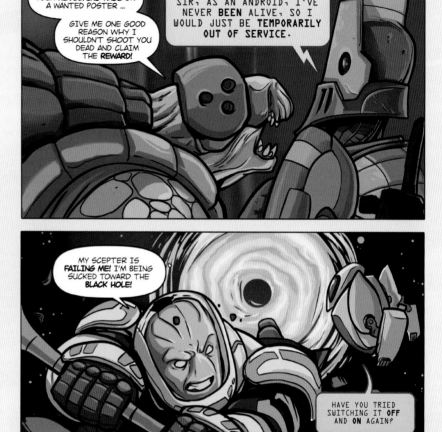

5. HOW TO DRAW MONSTROUS COMIC HEROES

Discover how to draw the mightiest, most monstrous menaces. This chapter is packed with guides to drawing exaggerated muscles, tough textures, dramatic lighting, and spooky scenarios.

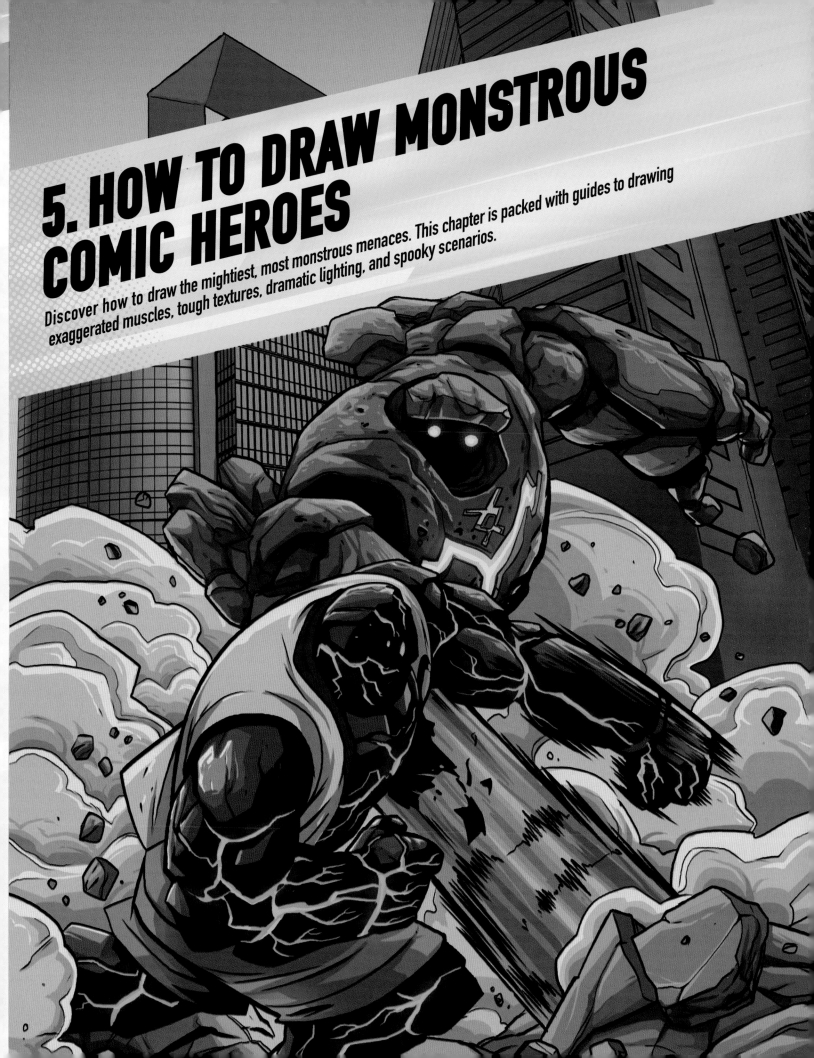

BULKED UP

Megaton is an example of a muscle-bound character. His oversized arm muscles mean he can't bring them close to his body, so he takes up lots of space and seems even more imposing. A powerful figure like this is rarely seen in a relaxed pose. His hands are usually drawn as fists or in a gripping position.

NAME: MEGATON

REAL IDENTITY: Samson Lepani

POWERS: Can absorb impacts and deliver highly explosive punches.

ORIGIN: Fisherman Lepani was shipwrecked near a foreign atom-bomb test on Bikini Atoll, which caused him to mutate into a crazed human detonator.

STRENGTH	◈◈◈◈◇
INTELLIGENCE	◈◈◇◇◇
SPECIAL POWERS	◈◈◈◈◇
FIGHTING SKILLS	◈◈◇◇◇

CRACKING UP

Megaton has dark skin, which seems burned. Cracks appear in it, revealing the heat of a nuclear furnace just below the surface. It's almost as if he is bursting with power. A glow of green appears through the cracks to show the heat and energy within him.

LOOK SHARP

Though Barb has skin like a thorny lizard, she is human in shape. Draw Barb's anatomy first before adding spikes to her. Don't make them all point upward, but have each tiny triangle point outward from wherever it is sprouting on her body.

HERO OR VILLAIN?

Not every character can be defined as a hero or villain. Some may mean to be good but make mistakes that lead them down the wrong path. Though she once willingly worked for an evil scientist, Barb now feels anger at being turned into a "monster", and seeks retribution and a cure. Her pose is awkward and defensive. She needs help, but has serious trust issues.

NAME: BARB

REAL IDENTITY: Barbara Harrow

POWERS: Has spine-firing, thorny skin.

ORIGIN: Assistant turned involuntary test subject of the evil genetics expert Dr. Sabine, Harrow has grown into a thorny, super-strong fighter with a spiky personality.

STRENGTH ◆◆◆◆◇
INTELLIGENCE ◆◆◆◇◇
SPECIAL POWERS ◆◆◆◆◇
FIGHTING SKILLS ◆◆◆◇◇

MAJOR MUSCLES

For the mightiest of heroes and villains, you have to look at bodybuilders to see similar anatomy. Here's how to bulk up your super-strong characters.

The average fit male, in the first picture, has well-defined muscles from regular exercise. To his right is the mega-muscled body of superhero Heavyweight.

The chest can be twice the size of a regular guy's. Beneath the chest is the bottom of his rib cage, which follows the curve underneath his chest.

Heavyweight's neck is as wide as his head, with large triangular muscles (trapezius) on each side.

The biceps on the arms are as large as Heavyweight's head. Even smaller muscles that surround them appear significant on this pumped-up champ.

The serratus anterior muscles connect his rib cage to his shoulder blades.

Two pairs of abs (abdominal muscles) are on display above the belt. There are three pairs of abs altogether forming his "six-pack".

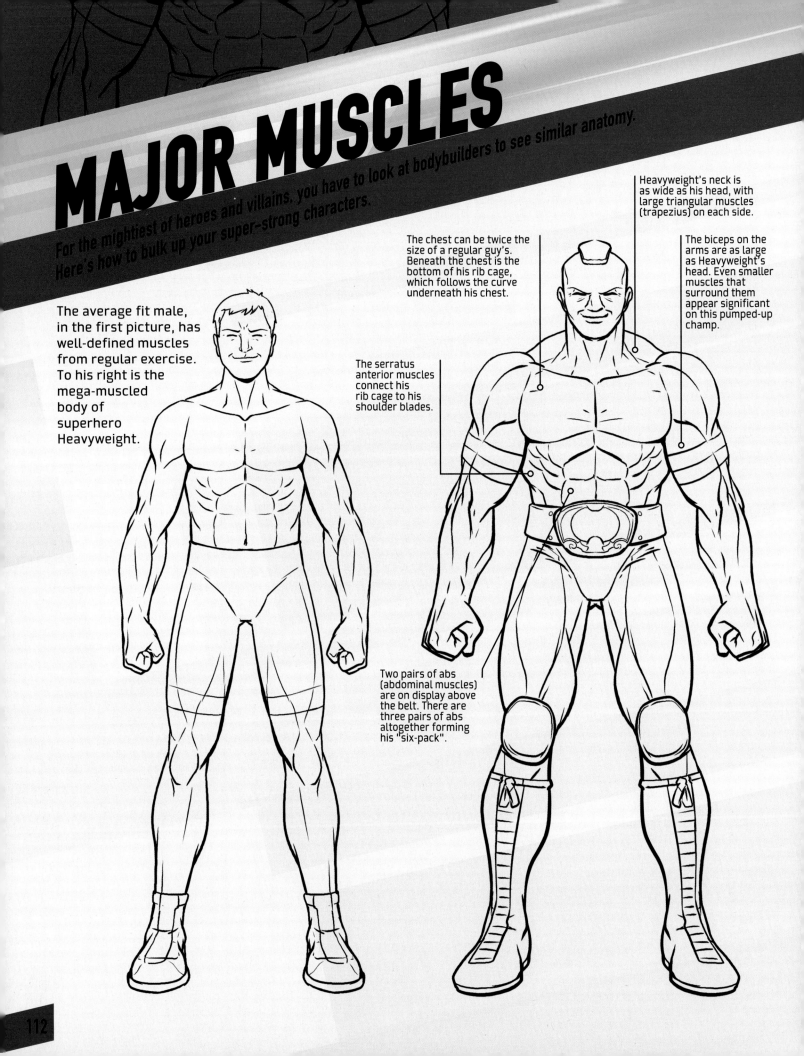

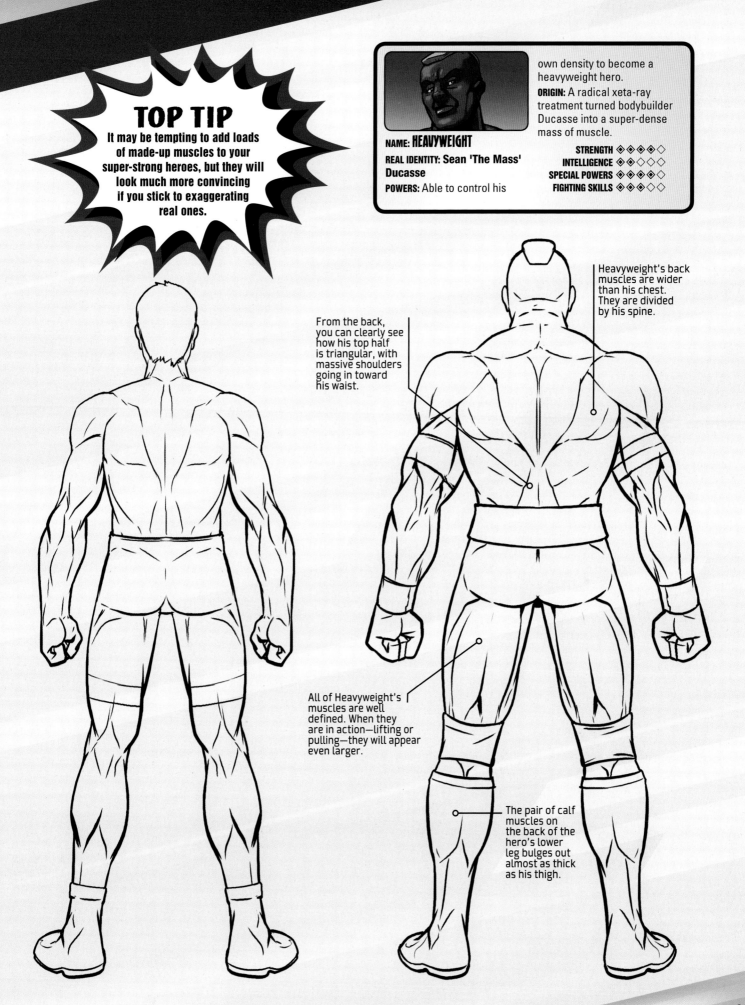

NAME: **HEAVYWEIGHT**

REAL IDENTITY: **Sean 'The Mass' Ducasse**

POWERS: Able to control his own density to become a heavyweight hero.

ORIGIN: A radical xeta-ray treatment turned bodybuilder Ducasse into a super-dense mass of muscle.

STRENGTH ◇◆◆◆◇

INTELLIGENCE ◆◆◇◇◇

SPECIAL POWERS ◇◆◆◆◇

FIGHTING SKILLS ◆◆◇◇◇

From the back, you can clearly see how his top half is triangular, with massive shoulders going in toward his waist.

Heavyweight's back muscles are wider than his chest. They are divided by his spine.

All of Heavyweight's muscles are well defined. When they are in action—lifting or pulling—they will appear even larger.

The pair of calf muscles on the back of the hero's lower leg bulges out almost as thick as his thigh.

TOUGH HIDES

Rock, fur, metal, and timber—here's how to give your towering titans some unusual skin types.

NAME: MENHIR

REAL IDENTITY: Menhir

POWERS: Super-strength, tough, stonelike body.

ORIGIN: Menhir was brought to life from a Bronze Age standing stone by worshipers of the ancient ways.

STRENGTH	◆◆◆◆◇
INTELLIGENCE	◆◇◇◇◇
SPECIAL POWERS	◆◆◆◆◇
FIGHTING SKILLS	◆◆◇◇◇

STONE COLD

Menhir is a man of rock, with limbs replaced by slabs of granite. To draw his body, replace human muscles with uneven, rocky shapes. Add a few thin cracks and scratches over the stones. When inking, leave a few spots and cracks showing in the shadows.

METAL MAN

NAME: STEEL MACE

REAL IDENTITY: Dr Rachid Zafar

POWERS: Super-strength, tough steel-like body.

ORIGIN: Rogue scientist Zafar experimented with metals found on an alien world. He found a way to make liquid metal bond with his skin, making him bulletproof.

STRENGTH ◇◇◇◇◇◇
INTELLIGENCE ◇◇◇◇◇◇
SPECIAL POWERS ◇◇◇◇◇◇
FIGHTING SKILLS ◇◇◇◇◇◇

For Steel Mace, the metal-skinned character, highlight the polish on his body by using thick, curvy lines that follow his muscle shapes. Break up these lines with the odd semicircle where a light source reflects on him, with gaps between the segments on his skin.

FOREST GUARDIAN

NAME: TREE TITAN

REAL IDENTITY: "He who embodies the forest"

POWERS: Tree-like body can grow in size and produce strong, woody tendrils.

ORIGIN: The spirit of the South American forests has returned to punish those who destroy the natural world.

STRENGTH ◇◇◇◇◇◇
INTELLIGENCE ◇◇◇◇◇◇
SPECIAL POWERS ◇◇◇◇◇◇
FIGHTING SKILLS ◇◇◇◇◇◇

Tree Titan is an ancient tree spirit brought back to life. His vaguely human shape is made up of branches and roots. His fingers and toes are tangled. His bark skin appears wrinkled with thin, curved lines at the points where the branches twist.

OUT OF THE SHADOWS

Some monster comics are about hulking monsters smashing up cities. Others are about creating a spooky atmosphere. Here's how to build tension before your monster even appears!

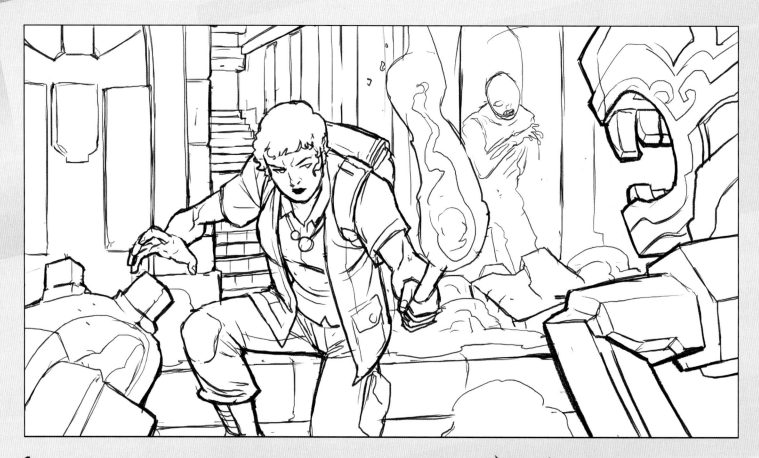

1. In this scene, monster hunter Elsa Nyberg is exploring a ruined crypt. It's a scary situation for sure, but how do you make the most of it? These pencil sketches do not make use of the light source.

TOP TIP

Position a light source to make the most of a spooky scene. Here, the low torchlight creates tall, black shadows on the walls. A light above would remove those.

2. The main light source, above, is the flaming torch in Nyberg's hand. It lights up Nyberg's worried face from below and casts her shadow on the wall behind. Now the scene is more suspenseful.

3. In the finished ink drawings, below, Nyberg's shadow looks like a creature creeping up on her. Highlights in the shadows pick out cracks in the wall, and the torn clothes and bones of the figure hiding in the alcove.

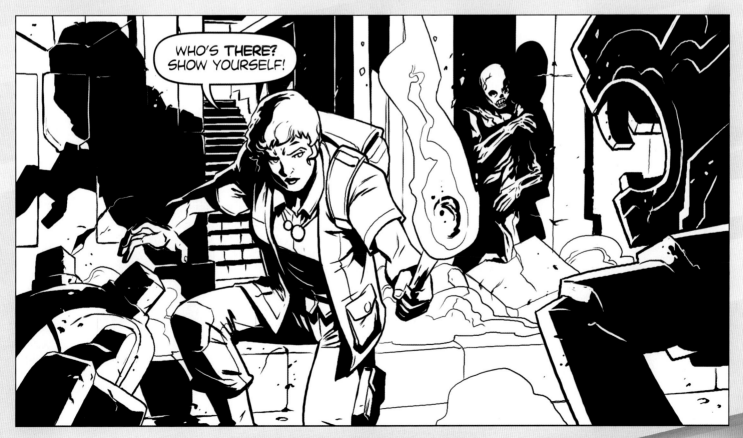

BODY LANGUAGE

How your characters stand can express as much about their personality or mood as their face or dialogue. Here are some poses that say a lot.

ARROGANT POSE

Corrosia is the ruler of the Dark Realm. You can tell she's the boss because of her dominant stance—upright, with shoulders back, chin up, and chest out. She stands tall and looks down on those around her. Without her sneer, the same pose would work for the leader of a team of heroes.

NAME: QUEEN CORROSIA

REAL IDENTITY: Corrosia

POWERS: Her touch causes swift aging and decay.

ORIGIN: Mistress of the Dark Realm, Corrosia offers wealth and power in exchange for an early death.

STRENGTH ◆◇◇◇◇
INTELLIGENCE ◆◆◆◆◇
SPECIAL POWERS ◆◆◆◇◇
FIGHTING SKILLS ◆◇◇◇◇

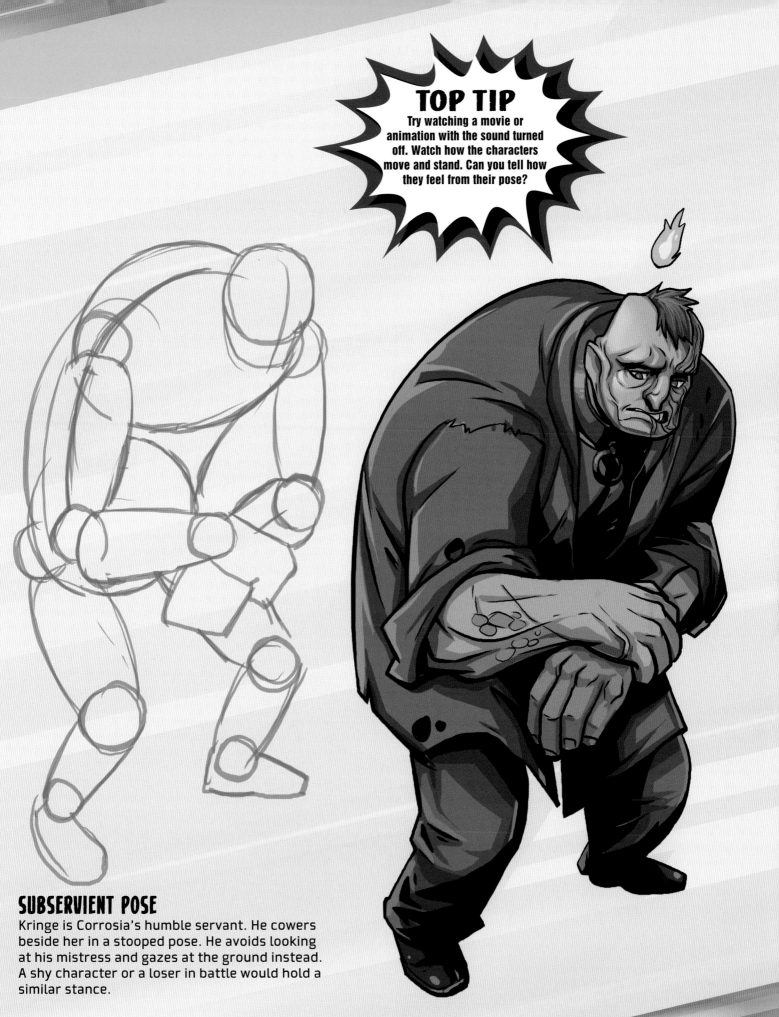

TOP TIP
Try watching a movie or animation with the sound turned off. Watch how the characters move and stand. Can you tell how they feel from their pose?

SUBSERVIENT POSE
Kringe is Corrosia's humble servant. He cowers beside her in a stooped pose. He avoids looking at his mistress and gazes at the ground instead. A shy character or a loser in battle would hold a similar stance.

119

AGGRESSIVE POSE

From the pose, the Geckoid is not looking for friends. Dinner, maybe! He's leaning forward, raising his clawed, sticky hands and waving his thorny tongue like a wild animal trying to frighten away intruders. This pose works for any tough character spoiling for a fight.

NAME: GECKOID

REAL IDENTITY: Eddie Marsh

POWERS: Super-strength, can cling to walls and ceilings, thorny, adhesive tongue.

ORIGIN: Sewage worker Marsh mutated into a monster after being bitten by a lizard that had been infected with pollutants.

STRENGTH ◇◇◇◇◇
INTELLIGENCE ◇◇◇◇◇
SPECIAL POWERS ◇◇◇◇◇
FIGHTING SKILLS ◇◇◇◇◇

TOP TIP
Keep your sketchbook handy to draw people in different poses. Your drawings don't have to be detailed—they just need to capture a natural gesture or a posture.

TERRIFIED POSE

Eyes and mouth wide open, hands raised, body leaning backward—this guy looks scared, and you would, too, if you came across Geckoid!
The body takes a defensive position when frightened, and leans away from the threat.

121

SPOOKY SETTINGS

Using different shading textures can add depth and atmosphere to your story settings. Practice using pens and brushes to match the marks used in these pictures.

Here are some different texture patterns you can use to shade your scary scenes.

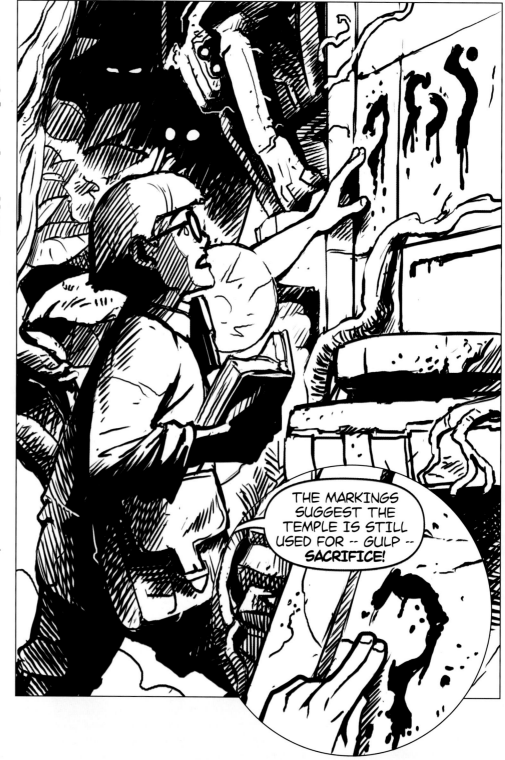

TEMPLE RUINS

➤Ruins are great for atmosphere. This building has crumbled from centuries of neglect, or maybe a terrible event caused its destruction. A jungle setting suggests it is a lost temple, full of mystery and possibly still in use! Spooky statues, carvings, or unusual painted symbols can suggest a gruesome past.

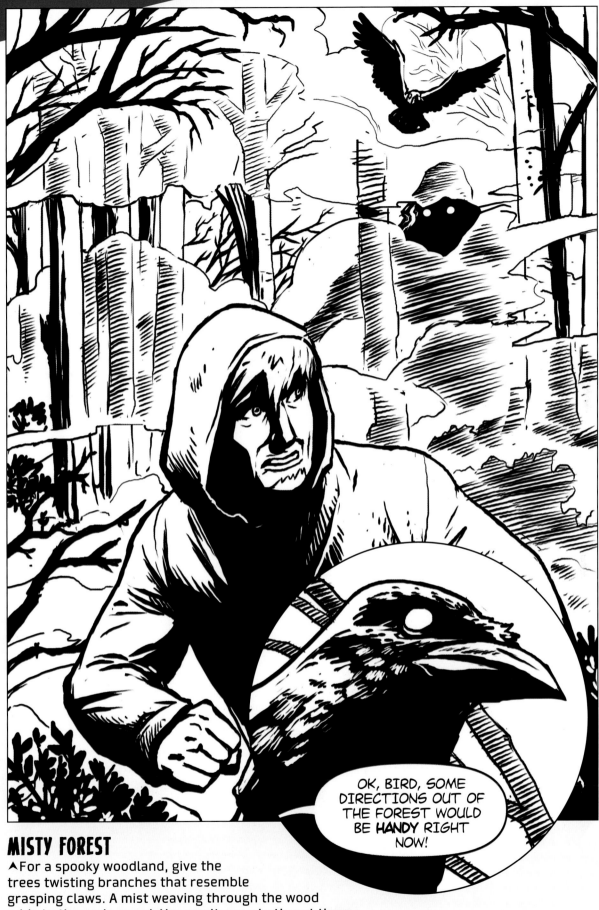

MISTY FOREST

▲For a spooky woodland, give the
trees twisting branches that resemble
grasping claws. A mist weaving through the wood
adds to the eerie mood. You can't see what's out there,
but what you can see looks worse than it is! A crow with its
bright white eyes seems to be spying on the protagonist.

DARE YOU ENTER...

Following reports of nightly attacks, monster-slayer Simon Cleaver has traced large animal tracks to the abandoned home of the cursed Lord Lupei. But what is the best way to show his dramatic entrance?

NAME: SIMON CLEAVER

REAL IDENTITY: Simon Cleaver

POWERS: Immunity to vampire bites. Expert on monster killing.

ORIGIN: As a child, Cleaver saw both his parents killed by vampires. With a magical sickle that makes him immune to their bite, he swears to destroy all such monsters.

STRENGTH	◆◆◇◇◇
INTELLIGENCE	◆◆◆◆◇
SPECIAL POWERS	◇◆◇◇◇
FIGHTING SKILLS	◆◆◆◆◇

1. As the hero steps through the door, moonlight from outside casts his shadow inside the mansion. Though this symmetrical view is a good image, it is not the best dramatic angle. And with the hero and monsters mostly in silhouette, you can't see much detail.

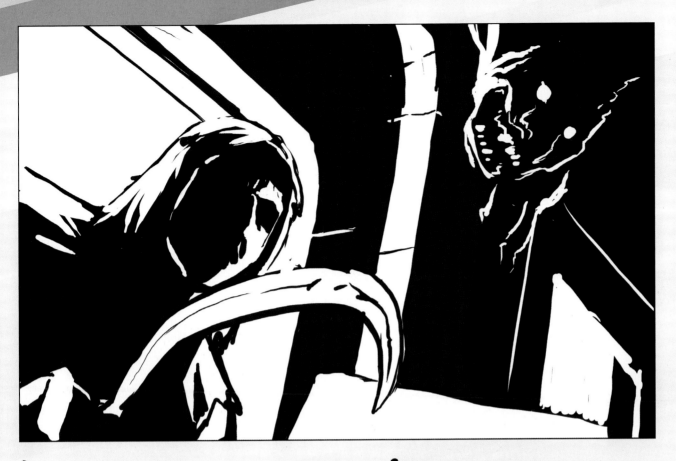

2. This is a more exciting angle, with Cleaver and his sickle weapon in the foreground. But although we can see a monster hiding above him, we can't see how large or powerful it is. We need Cleaver to seem more in peril.

3. This is a better dramatic angle, looking down on the hero. You can see more of the monsters' shapes, with highlights picking out their details. From this angle, they also appear much larger than Cleaver.

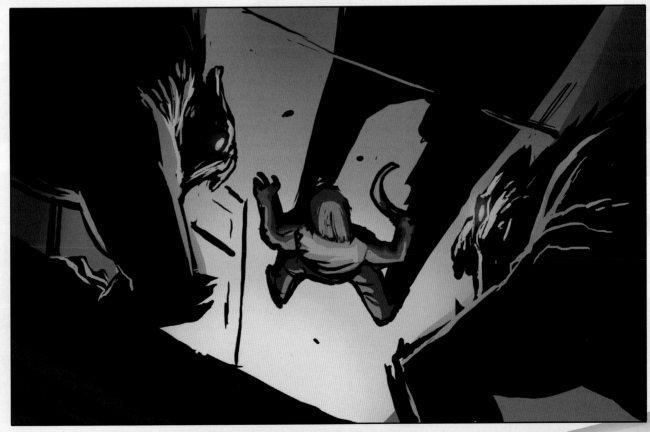

... THE HOUSE OF FEAR?

For the finished scene, a green tint was chosen to create a more supernatural atmosphere. Crosshatched inks have been used to build up the shadows and muscles on the monsters.

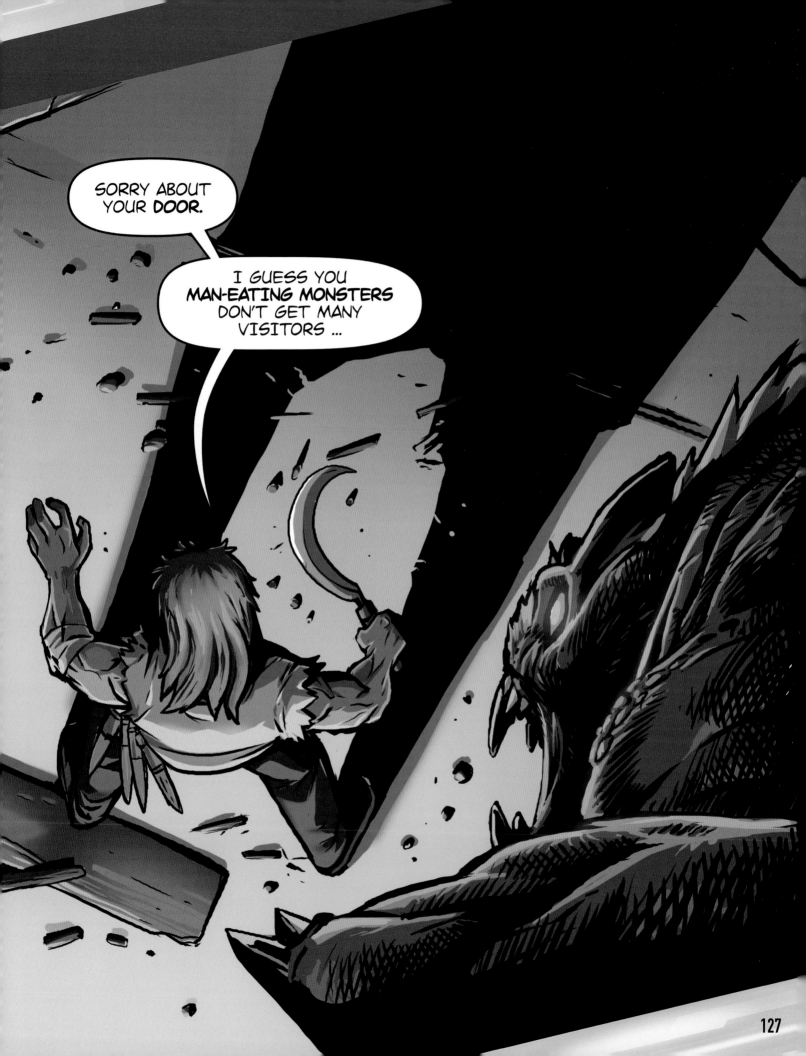

GRUESOME GALLERY

Why not invite some fearsome friends over for your monster-filled comic book story? Here are a few creepy characters you could introduce to your tale.

GARGOYLE

Once a stone sentinel over a church, the gargoyle has come alive to flap his batlike wings and spook anyone foolish enough to enter his turf at night. Add a dotted texture to his body to show that he is made of pockmarked stone.

CYBER-ZOMBIE

Kept barely alive by transplants and tech, the cyber-zombie is looking for new organ donors. A few inky patches of darkness show where he needs some medical attention. Shade in his fleshy parts with fine lines to contrast with the shiny metal tech.

WOLF MAN

The moon lights the wolf man from behind, leaving most of him in shadow. His fur is shaded with dashes that follow the shape of his muscles. Highlights reveal his torn shirt, bright eyes, and blood dripping from his fangs.

SWAMP CREATURE

The swamp has come alive in human form! Shade the patches of mud, moss, grass, and vines with crisscrossed lines that get thicker for the darker patches. This technique is called **CROSSHATCHING**.

6. HOW TO DRAW MYSTICAL COMIC HEROES

Prepare to enter a new realm. You will need to summon all of your magical drawing skills to weave spells, draw powerful relics, and bring to life strange new worlds.

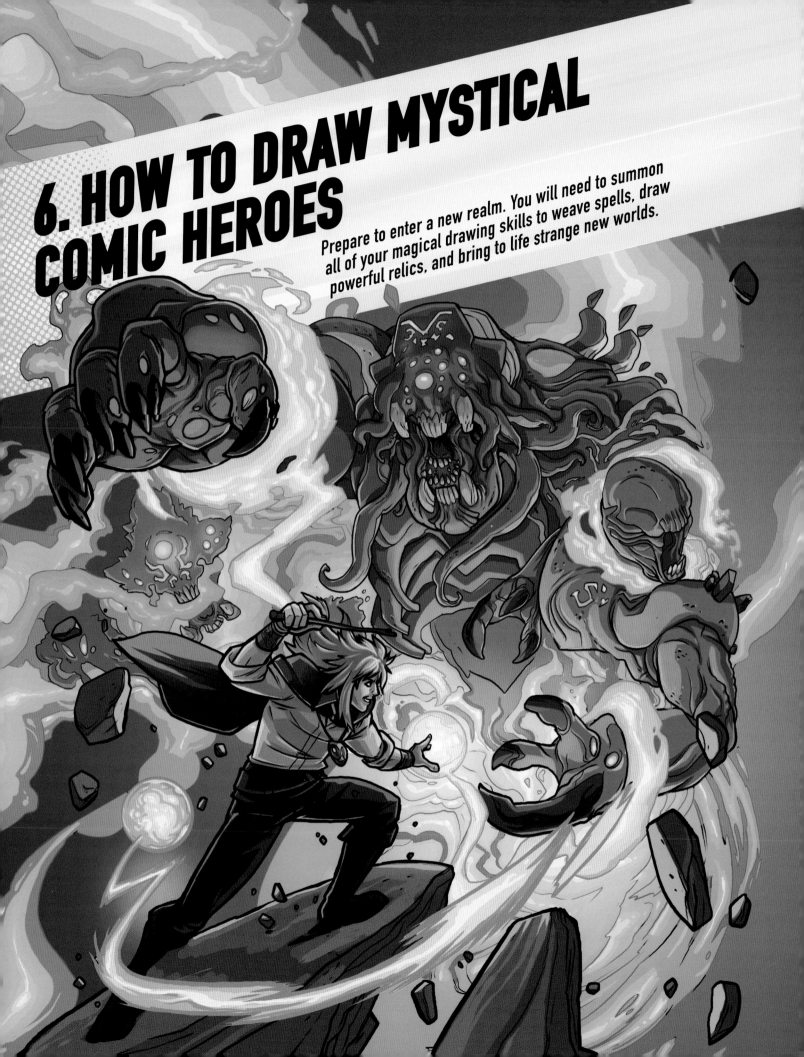

SUPERNATURAL SQUAD

Who will come forward to defend Earth from supernatural forces? Here are some suggestions for arcane warriors and masters of magic.

KNOWLEDGE IS POWER

Where will your mystic character derive their power from? Madame Hex's magical power comes from the use of language to convince others to see what she wants them to. With her powers of persuasion, she weaves words into reality. Persuasion is a strength equal to physical force.

STRENGTH AND WEAKNESS

Many of the greatest superheroes are hugely powerful in some ways, but vulnerable in others. This creates an interesting contrast. Madame Hex is a vital and powerful member of Earth's magic defense force, but she has needed a wheelchair to aid her mobility since she was a child.

NAME: MADAME HEX
REAL IDENTITY: Zandra Dicere
POWERS: Able to alter other people's perceptions.
ORIGIN: Zandra discovered a long-lost magic language that persuades others to see what they are told.

STRENGTH ◇◇◇◇◇
INTELLIGENCE ◇◇◇◇◇
SPECIAL POWERS ◇◇◇◇◇
FIGHTING SKILLS ◇◇◇◇◇

CUTTING A DASH

Magical heroes rarely wear the tight spandex costumes popular with muscular superheroes. Ethan Ether thinks of himself as one in a long line of magicians, so he wears a short cloak like a nineteenth-century mage, but with a modern swagger. Magic is the new rock 'n' roll, you know!

GROWING UP

Ethan's father, Edward, was also a magician, but Ethan is very different from his dad. Edward was thoughtful and restrained, but Ethan is flamboyant and loves to show off his magical talents. This vanity could be his downfall. If your characters have flaws, part of your story can be showing how they learn from their mistakes to become better heroes.

NAME: ETHAN ETHER

REAL IDENTITY: Ethan Etherington

POWERS: Able to channel the powers of past magicians with the same wand passed through generations.

ORIGIN: At age 16, Ethan received the gift of a wand from his missing magician father, whose spirit guides him.

STRENGTH ◆◆◇◇◇
INTELLIGENCE ◆◆◆◆◇
SPECIAL POWERS ◆◆◆◆◇
FIGHTING SKILLS ◆◆◆◇◇

BACKGROUND CHECK

Ezora is from Louisiana and has a Creole background. Creole people have their own culture and language, so Ezora might sometimes use a few Creole words and may refer to her home when talking to her teammates. If you create a character with background different from your own, it is essential to do research to get the details right. What you find out could inspire a new story!

DRAWING THE INVISIBLE

Dream Diviner's pose shows her reaching out and concentrating as she communicates with a spirit. She can see and hear beings that are dead or alive in nearby dimensions. These beings are invisible to everyone else. Of course, in a comic book, you can draw the ghosts and beings she sees, but make it clear that no one else can see them.

NAME: DREAM DIVINER

REAL IDENTITY: Ezora Aurieux

POWERS: Can communicate with the spirit realm and see other-dimensional beings.

ORIGIN: Born during a unique alignment of astral events, Aurieux has the gift of "spirit sight" which lets her see beyond the material realm.

STRENGTH ◈◈◈◈◇
INTELLIGENCE ◈◈◈◇◇
SPECIAL POWERS ◈◈◈◈◈
FIGHTING SKILLS ◈◈◇◇◇

MAGICAL TRANSFORMATION

With the right enchantments, even a down-to-earth guy can be turned into a mystic warrior. As a soldier, Ángel Vasquez was used to fighting traditional wars, but following a ritual he was put through by a mystic cult, he is now protected against supernatural attack, and his soul-fire sword can harm the otherworldly monsters he faces.

MODERN MEDIEVAL

Historic warriors are a great source for character and costume inspiration. Quester is a modern-day warrior in a medieval-style armor, replacing heavy metal with tough, lightweight materials, such as Kevlar. He's not afraid of using tech on supernatural enemies, either; his sword fires power blasts and can raise a force field.

NAME: Quester

REAL IDENTITY: Ángel Vasquez

POWERS: Combat skills, pain-resistant. Sword fires power blasts and raises force shield.

ORIGIN: Soldier Vasquez was captured by occultists who put him through a ritual that turned him into a supernatural warrior.

STRENGTH ◇◆◆◇◇◇
INTELLIGENCE ◆◆◇◇◇◇
SPECIAL POWERS ◆◆◆◇◇◇
FIGHTING SKILLS ◆◆◆◇◇◇

133

MODERN MAGE

1. WIREFRAME

Start drawing Charm's pose using a stick figure with an oval for the head and circles for joints. Give her a dramatic **POSTURE**, but make sure the proportions are correct for her body, arms, and legs.

2. BLOCK FIGURE

Now fill out Charm's figure using 3D shapes. Even though she will be wearing a flowing dress, you need to figure out where her legs fit beneath the gown.

3. FINISHED PENCILS

When you are happy with the figure, you can draw the basic shape of her dress flowing over her body. Her clothing follows her curves, with wind from the right blowing her skirt to the left. A scarf curls around her neck, and her long hair flows wildly in the wind.

NAME: CHARM

REAL IDENTITY: Charmaine Bryant

POWERS: Can summon supernatural creatures to her aid through the use of mystical artefacts.

ORIGIN: After trying to save a homeless woman from mystical attack, Charmaine received her magical jewels as a reward.

STRENGTH ◆◇◇◇◇
INTELLIGENCE ◆◆◆◆◇
SPECIAL POWERS ◆◆◆◇◇
FIGHTING SKILLS ◆◆◆◆◇

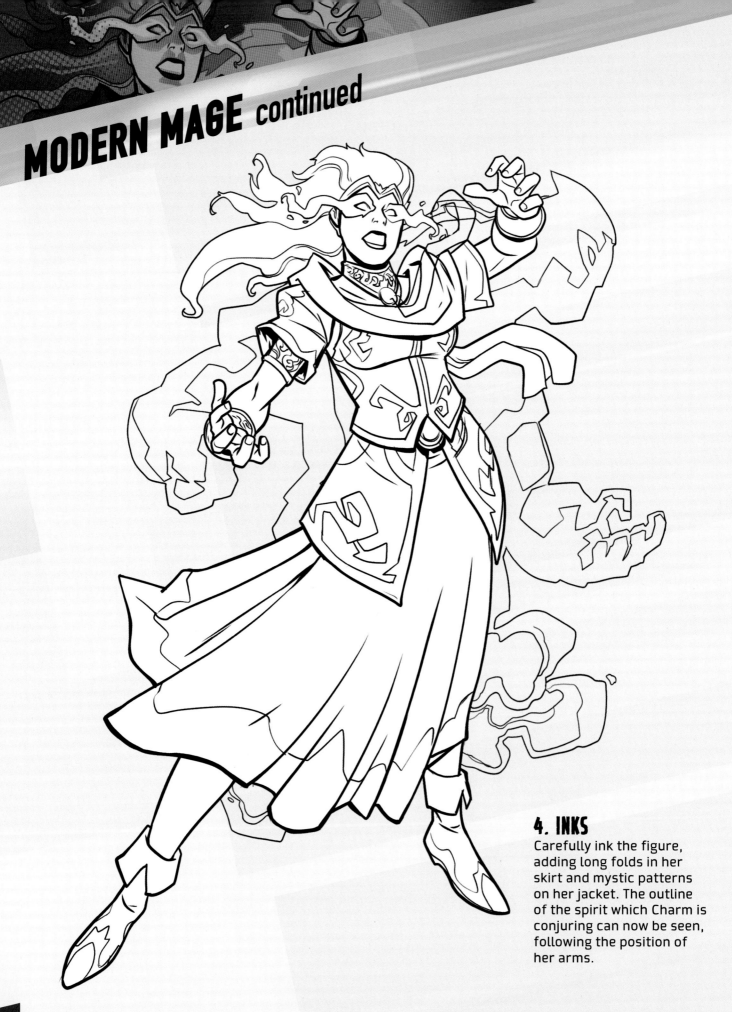

4. INKS

Carefully ink the figure, adding long folds in her skirt and mystic patterns on her jacket. The outline of the spirit which Charm is conjuring can now be seen, following the position of her arms.

The spirit coming from Charm's amulet is part way on its journey from another dimension. Only the top half of its body is visible, but you can still build up its form using a wireframe and 3D shapes. Since it is not completely solid, use colored instead of black outlines for the finished artwork, and show parts of the background through its body.

5. COLORS

The finished colors add highlights and shadows to Charm's hair and dress, as well as the ghostly spirit. The pale blue lights shining from Charm's eyes show that she is using her supernatural powers.

MYSTIC REALM

In the magical Dread Dimension, the rules of perspective don't apply. Here's how to ground your mystical heroes in a realm without reason.

1. THE ROUTE

In this scene, Quester, the supernatural warrior, has to find his way across a magical landscape to reach the Kingdom of Curses. The hero needs something to stand on and a path to the kingdom's ruins. The path has many curves.

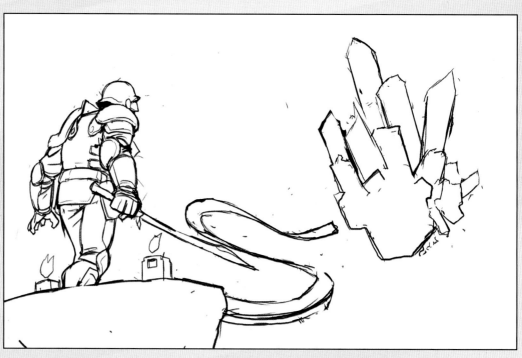

2. STRUCTURE

Before any detail is added, large shapes, such as clouds and floating islands, plus areas of darkness, are marked to give the weird landscape some structure and to help lead your eye toward the hero's destination.

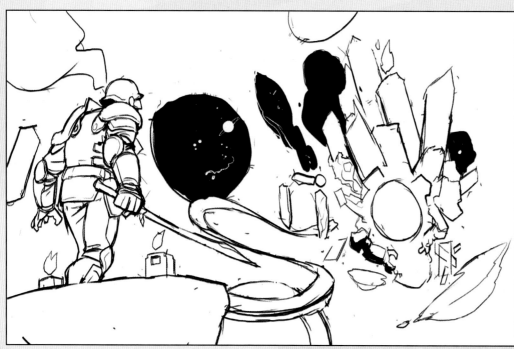

3. WILD WORLD

It's time to let your imagination flow, breaking up the path with steps and strange doorways, then adding abstract shapes and monstrous creatures to the weird realm.

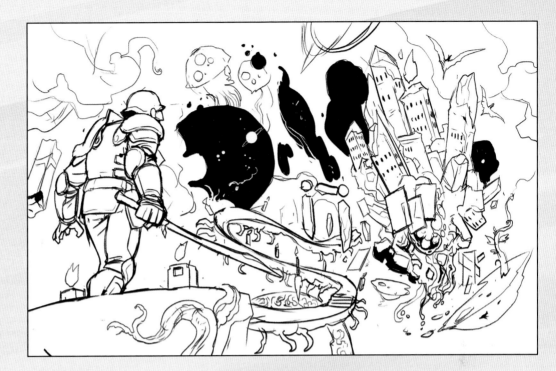

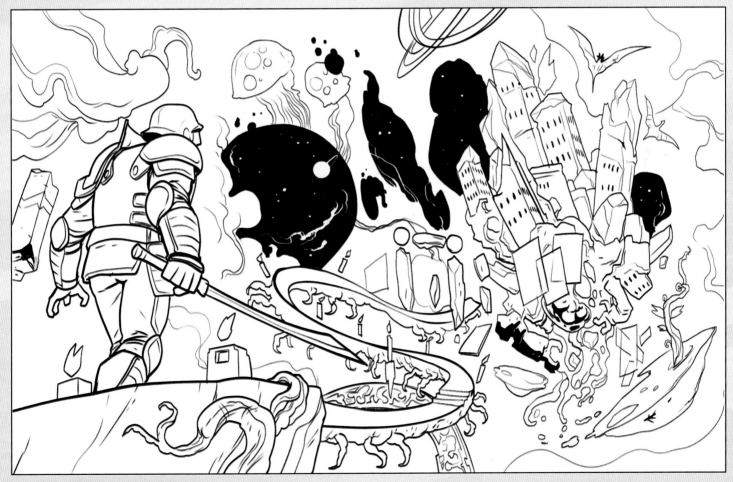

4. THE PATH IS REVEALED

The finished, inked scene looks bizarre, but you can still find your way around it. The reader may not know what every magical thing is, but the objects look solid, and there are enough familiar shapes to lead both the reader and Quester in the right direction.

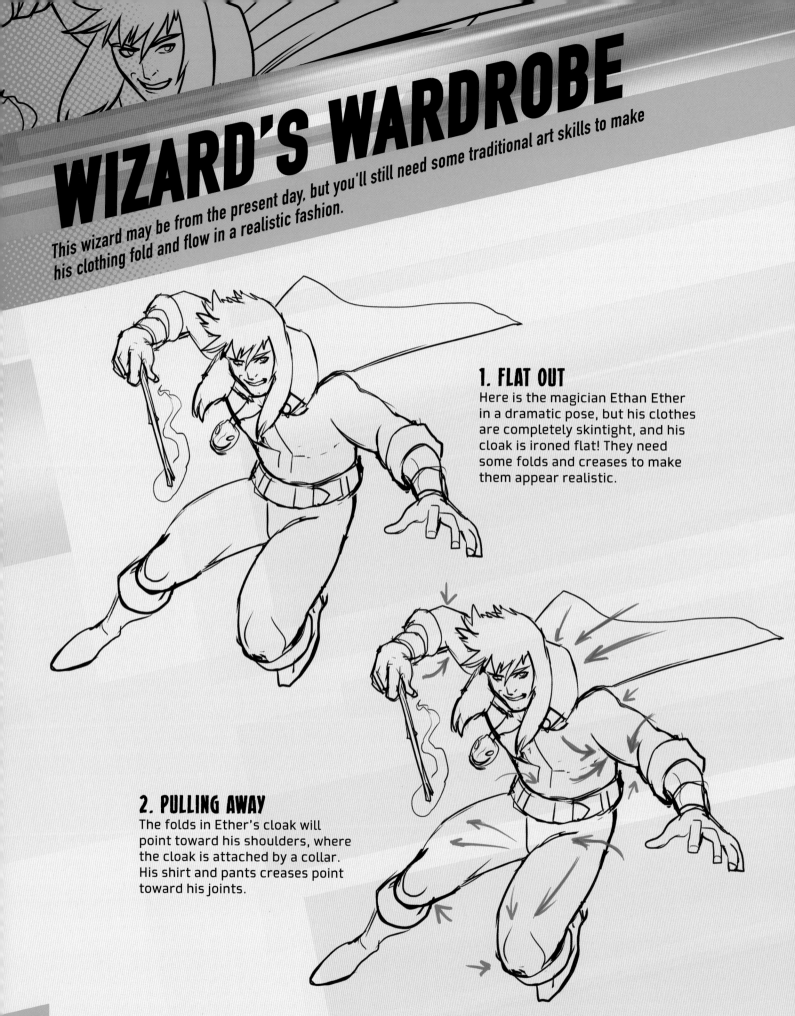

WIZARD'S WARDROBE

This wizard may be from the present day, but you'll still need some traditional art skills to make his clothing fold and flow in a realistic fashion.

1. FLAT OUT

Here is the magician Ethan Ether in a dramatic pose, but his clothes are completely skintight, and his cloak is ironed flat! They need some folds and creases to make them appear realistic.

2. PULLING AWAY

The folds in Ether's cloak will point toward his shoulders, where the cloak is attached by a collar. His shirt and pants creases point toward his joints.

FOLD OUT

Increase your crease knowledge with this example of how a pair of pants folds over the body. See how the long folds point toward the knees, where the material is stretched tight. Creases appear behind the knees where the material is baggier.

3. TUCKED IN

The material bunches up under Ether's armpits, where his sleeves are rolled up and where his joints bend, opposite his elbows and knees and at the top of his thighs.

4. IN FULL FLOW

All the folds and creases have been put in place, and the figure is inked with a brush. Careful brushwork shows the folds starting with a point, getting wider, then ending with a point again. The finished effect is more realistic and dynamic.

MAGIC TRICKS

What does a spell look like? You can easily show the effect, but you'll also need to show the spell-casting.

SPELL

◄ Here, Charm is twisting her fingers into special spell positions. Circles of magic light surround her hand, and streams of mystic force radiate outward, ready to be directed at their target.

FORCE SHIELD

➤ In this case, the magical object—a protective shield—is drawn in midair. A light trail shows its boundary, while a semitransparent color shows where the shield is in place.

TOP TIP
While superhero power bolts are usually shown taking a direct path, mystical spells often follow curving routes as if they have their own minds—perhaps they do!

RUNES
◄ Spells may be in an ancient language. The magic "words" in runes and symbols appear to float in the air, as they demonstrate their power.

BOLTS
➤ Charm has generated bolts of mystic energy to strike a foe. Once summoned into the palms of her hand, she hurls them toward her enemy.

143

RELICS OF POWER

Objects hold great power for magicians. Here are some relics worth collecting for your mystic heroes. Every magical object should have its own story ... what will yours be?

AMULET

➤ This amulet holds the Orb of Voltain, a stone of ancient, possibly extradimensional origin. The sparkles in the gem suggest a whole galaxy is contained within it. Worn around a magician's neck, it offers protection against evil incantations.

BOOK

➤ Containing the wisdom of the witch Magluthra, this book of spells and remedies was kept safe by the Order of Z'Tor for centuries until the evil Lord Tralon stole it from their library. The worn bindings and leather show its age. A strong lock suggests its secrets need protecting.

STAFF

➤ Cut from the same willow as the cane of the legendary mage Merlyn, this staff of power is inscribed with powerful spells. It can lead its bearer away from danger and discharge the lightning of wrath upon enemies. Look at old languages, such as Viking runes, then design your own language for writing spells.

CRYSTAL

◀ Stolen from the Cave of the Fair Elves, this crystal contains a source of fairy magic. Combined with the right words, it allows its bearer to use many powerful enchantments. Mystical relics often change hands and can lead to a story with good and evil magicians fighting for ownership.

FORCE SWORD

➤ The Nornsword, wrought from rare norn metal, can cut and wound supernatural beings immune to other earthly weapons. Anointed with a spell of revelation by the wizard Amouthrir, it glows when faced with untruths. Adding a history, unique source, or engraving to a familiar weapon can turn it into an object of magic.

SHIELD

 The Shield of Styrig is said to be the same one that the wizard-slayer Styrig used to defeat the Coven of Kruel in the world before time. It can deflect any spell, reflecting it back to the one who cast it. Your comic book stories don't have to be set in the present day. Why not invent a magical past that was never described in the history books?

SUPERNATURAL STRIKE

Let's create a dramatic scene full of spells flying in all directions. Earth's champions of the light will need all their magical knowledge to keep the Sastorfrax twins from corrupting our world with darkness.

1. Figure out the positions of your heroes and villains in a small thumbnail sketch. The twins stand on a ledge above the heroes, making them appear even more dominant.

NAME: THE SASTORFRAX TWINS

IDENTITY: Guyal and Synge Sastorfrax

POWERS: In unison, they form one of the most powerful dark magic teams.

ORIGIN: The twin children of former Dark Lord Sastorfrax now combine their inherited mystic powers.

STRENGTH	◇◇◇◇◇
INTELLIGENCE	◇◇◇◇◇
SPECIAL POWERS	◇◇◇◇◇
FIGHTING SKILLS	◇◇◇◇◇

2. For the rough pencil sketches, the angle of the villains' ledge has been tilted for a more imposing view. Blue **PERSPECTIVE LINES** show the direction of the action, with the heroes pushing forward to the base of the ledge.

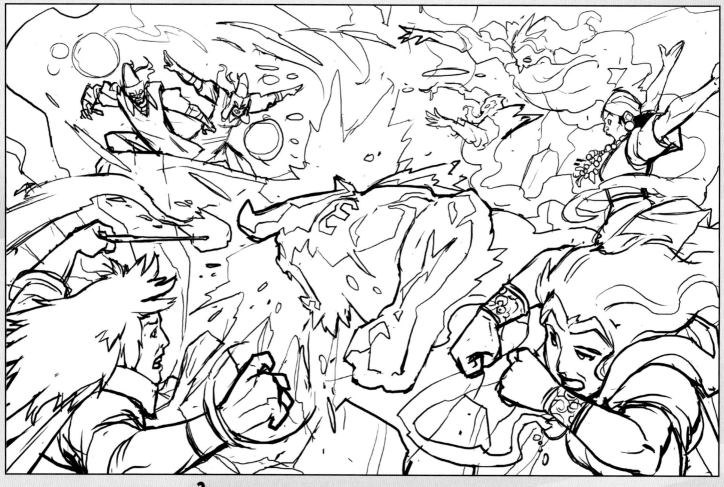

3. Tighten the pencil sketches, and outline a swirling magic storm raging around the twins, while mystic bolts go back and forth between the forces of dark and light.

TOP TIP
Magic spells can take any shape or path. Use them to guide your reader around the action. In this scene, magic swirls lead your eye from the heroes to the villains and back.

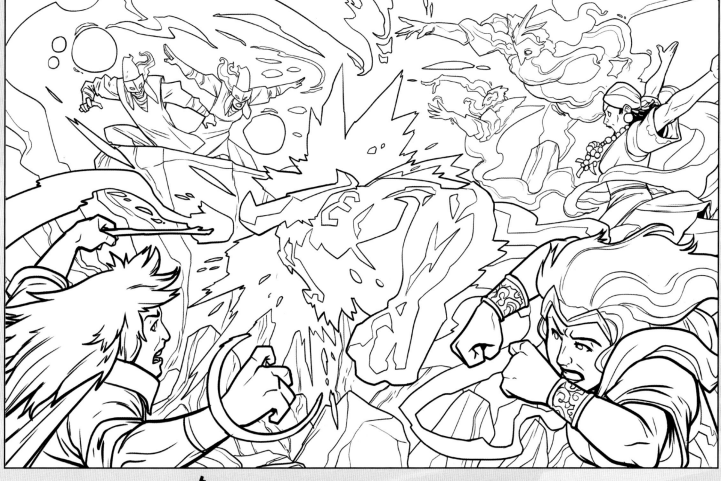

4. Carefully ink the pencil lines you want to keep with a brush or pen. Use a thicker outline for the characters in the foreground—Ether and Charm. You may want to use a color to outline the flashes of magical lightning and the ghostlike beings that Dream Diviner has summoned, as over the page ...

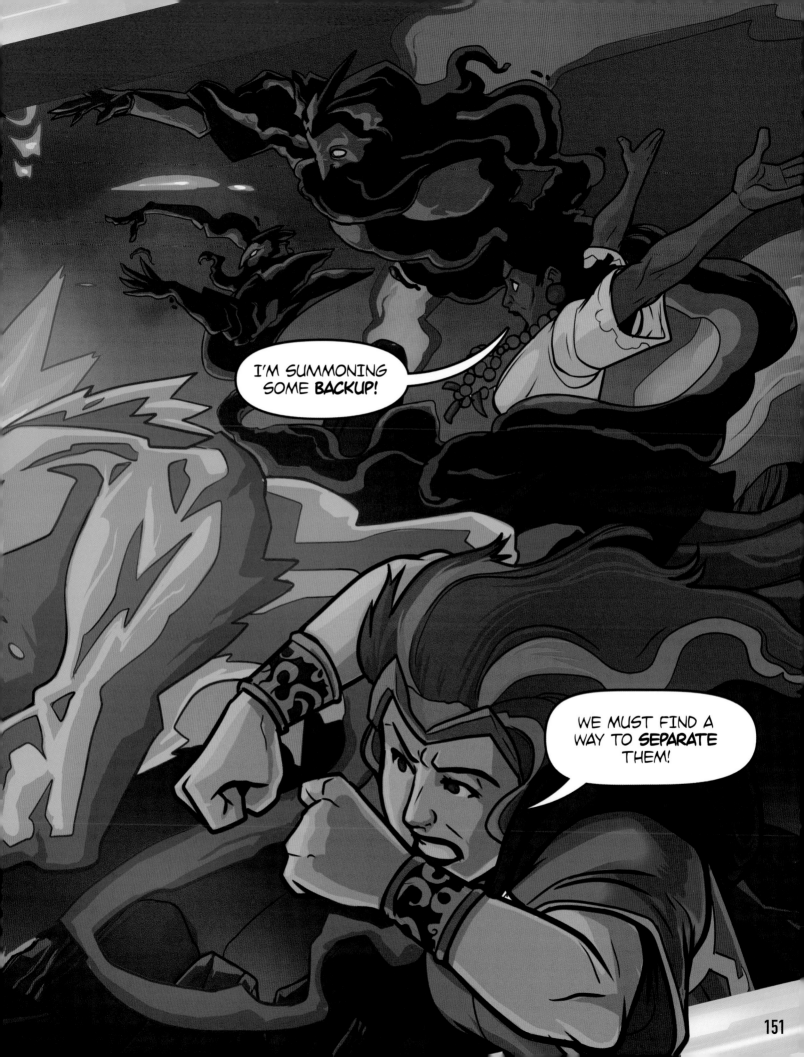

COVER UP

A front cover needs to grab the attention of a potential reader and give a clue to the excitement inside. Here are the essentials for selling your comic book classic.

You don't always need words on the cover, but in this case, Quester's quote adds to the drama.

Your comic will need a title. Usually, this will be the name of the lead character or team. Take time designing an eye-catching logo.

An amazing portrait of your story's hero or a dramatic scene with the hero struggling to survive works well. The image should make readers want to know more—who is this hero? How will he escape certain doom?

The inked outline is bolder than the lines used for the comic story inside, as if it is a blown-up comic panel.

THE NEXT LEVEL

Many artists don't write the stories they draw, but follow an author's comic script. Here is an example of a script page, plus an artist's thumbnail sketch of the layout. How would you draw this page?

PANEL 1, SCENE: KNOCKOUT AND THE CONCREATURE ARE FIGHTING ON THE CENTRAL CITY COURTHOUSE ROOF, FIVE STORIES HIGH. KNOCKOUT IS A SHORT BUT LEAN MIXED-HERITAGE FEMALE HERO. HER LONG HAIR IS TIED BACK. SHE WEARS A COSTUME THAT SHOWS OFF HER MUSCLES, LIKE A FEMALE KICK-BOXER, WITH STRAPPED BOOTS, ELBOW AND KNEE PADS, AND A WIDE BELT. THE CONCREATURE IS A ROUGH HUMAN SHAPE MADE OF GRITTY, GRAY CONCRETE IN BOTH HARD AND LIQUID FORM. HE HAS JUST THE HINT OF A HUMAN FACE. THE CONCREATURE LUNGES TOWARD KNOCKOUT, WHO PREPARES TO DEFEND HERSELF.

CAPTION: ABOVE THE CENTRAL CITY COURTHOUSE, KINETIC-ENERGY POWERED KNOCKOUT IS ON THE ROPES AGAINST THE CONCREATURE ...

CONCREATURE: I CAN CHANGE MY FORM TO LIQUID AT WILL! YOUR PUNCHES ARE POINTLESS!
KNOCKOUT: MAYBE ... BUT THEY LET ME WORK OFF **STEAM!**

PANEL 2, SCENE: KNOCKOUT SWINGS A PUNCH WITH HER RIGHT ARM BUT IT SINKS INTO THE CONCREATURE'S CHEST. THE CONCREATURE GRINS.

KNOCKOUT (THINKING): HE'S RIGHT ... I NEED KINETIC ENERGY TO MAKE MY PUNCHES EFFECTIVE, BUT HE'S SLOWING MY EVERY MOVEMENT!

CONCREATURE: AND FOR MY NEXT TRICK ...

PANEL 3, SCENE: KNOCKOUT LOOKS IN SHOCK AS HER FIST IS TRAPPED IN THE CONCREATURE'S CHEST UP TO HER ELBOW. THE CONCREATURE HAS TURNED HIS TORSO ROCK HARD AND IS EXERTING PRESSURE ON HER TRAPPED LIMB.

CONCREATURE: ... I'LL TURN MY BODY **ROCK HARD!**
KNOCKOUT: NYEERGHH!

PANEL 4, SCENE: KNOCKOUT IS WINCING WITH PAIN AND CONCENTRATION. SHE PUSHES THE CONCREATURE'S CHEST WITH HER FREE ARM, TRYING TO RELEASE HER TRAPPED ARM.

KNOCKOUT (THINKING): I NEED TO GET SOME KINETIC ENERGY FAST BEFORE HE CRUSHES MY ARM! AND I KNOW A WAY ...

PANEL 5, SCENE: KNOCKOUT PUSHES BOTH OF THEM OFF THE EDGE OF THE ROOF.

KNOCKOUT: READY FOR A FALL, **BLOCKHEAD?!**
CONCREATURE: ARE YOU **CRAZY?!**
KNOCKOUT (THINKING): HOPE HE TURNS SOFT FOR LANDING ... OTHERWISE IT'S LIGHTS OUT!

PANEL 6, SCENE: KNOCKOUT AND THE CONCREATURE HIT THE GROUND, WITH THE CONCREATURE TURNING TO SOFT CONCRETE TO FORM A LIQUID CUSHION FOR THEM BOTH.

SFX: SLOOOSH!

IDEAS BOARD

Never be stuck for inspiration for your comic books. Look around you, and keep notes and sketches in your own ideas book. Here are some images and phrases that could inspire characters and stories.

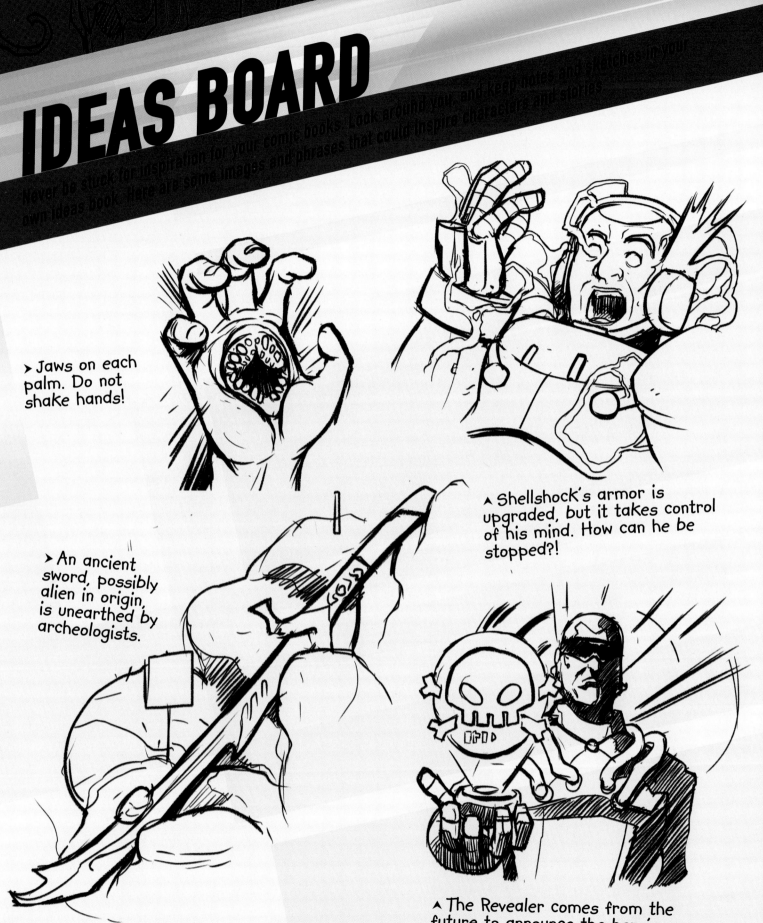

› Jaws on each palm. Do not shake hands!

› An ancient sword, possibly alien in origin, is unearthed by archeologists.

⌃ Shellshock's armor is upgraded, but it takes control of his mind. How can he be stopped?!

⌃ The Revealer comes from the future to announce the hero's death day.

THE EVIL SIGNALMAN HAS TAKEN CONTROL OF ELECTRONICS, INCLUDING CAR GPS!

TURN LEFT AT NEXT TURN ... AND KILL!

➤ Secret world trapped in crystal. Prison planet or hostages?

▲ Earth's new owner arrives with plans to rebuild it from scratch.

▲ Spylord's combination key can morph and unlock any door. What will he thieve next?

▲ Robot pests are multiplying!

▲ Amnesia has the power to steal memories! Will she discover the weapon launch codes?!

THE FUTURE OF COMICS

The way comics are made has moved on since the first superhero comics of the 1930s. Although many artists still use pencil and ink on paper, more are turning to technology to help them create and finish their artwork.

◄ As tablets have become lighter and more sophisticated, artists can use them for sketching and producing thumbnail layouts.

∨ Digital sketches or scanned pencil sketches on paper can be inked and colored on a computer using software and a graphics tablet. Effects, such as glows and gradual changes of color, can be applied easily.

➤ If the artist makes a mistake or changes their mind, it's easy to undo the last action on a computer or try several versions until they're happy.

➤ Letterers now create their own comic-book fonts and type the words into speech balloons placed on a layer above the digital artwork.

NOW, IT'S TIME TO SAY BYE! I HAVE ANOTHER PRESSING ENGAGEMENT! HA HA!

UGH! I 'VE BROUGHT DOWN BIGGER MONSTERS THAN YOUR MET

◀ The finished artwork files are delivered over the Internet to the publisher to check and be sent to the printer.

➤ It's not just creators using tech for comics. Readers, too, are enjoying their favorite titles, not just as printed copies but as digital comics on computers, tablets, and phones.

Of course, you don't need all this expensive tech to create a riveting comic-book adventure. A pen and paper is still the best way to get started. Ultimately, you still need the basic drawing skills and imagination to create a successful comic book, however it is made or read.

TO BE CONTINUED...

Now it's over to you! We hope we've given you some ideas for stories and characters, and some good advice on how to create a professional-looking comic book story. But don't stop here—artists never stop learning!

➤ Carry a small sketchbook with you at all times. You never know when an idea will hit. Draw every day, even if it's just a doodle. Keep your artistic muscles working!

You won't learn everything from comic books. Draw from real life. Watch how real people move, sit, and express themselves. Check out clothing, vehicles, and buildings. One day, you'll need to draw them as part of a story.

◀ Read plenty, and not just comics. Comics may inspire you to become a great comics writer or artist and show you ways of telling a story but books are full of ideas, too, with rich characters and situations. Many comic stories are based on classic myths and legends; go back to the source, and be inspired!

➤ Movies are also a great source of inspiration—and not just for story ideas. Pay attention to the direction and movement of the camera on actors, and the way light and shadows create mood. Planning your own comic book is just like being the director of your own movie, with panels instead of camera shots.

◄ Show your work to friends, share your drawings online, and go to comics conventions to show your art to professionals. Comic pros can give you tips on how to improve your work. And one day, it might be you in the chair, giving advice to the next generation of comic book creators!

GLOSSARY

BIRD'S-EYE VIEW
View looking down from above.

CAPTION
Introductory text on a comic panel, usually to set the scene or time.

CENTER OF GRAVITY
The point from which the weight of a body is said to act. On a figure, this is behind the belly button.

CHARACTER DEVELOPMENT
The gradual change of a character through experience.

CLIFFHANGER
A dramatic ending that leaves the reader wondering what happens next.

COMIC SCRIPT
An author's written plan for the plot of a comic book story.

CROSSHATCHING
A way of creating shade using intersecting parallel lines.

ESTABLISHING SHOT
A panel that shows where the action is set.

FORESHORTENING
A perspective effect that makes objects appear closer.

HORIZON LINE
Where the horizon would appear in a view, usually at eye height.

MEDIUM SHOT
A view that shows a figure in full.

MODEL SHEET
A drawing of a character used as reference.

MOTION LINES
Lines drawn behind a moving object or person to show that it is moving quickly.

PANEL
An individual frame in your story.

ONE-POINT PERSPECTIVE
A perspective with parallel horizontal and vertical lines, plus one vanishing point.

PERSPECTIVE
A way of representing three-dimensional (3D) objects in a picture.

PROTAGONIST
The leading superhero in your comic.

SPEECH BALLOON
Shape used in comic panel to hold character dialogue.

SPLASH PANEL
A big panel that takes up the space of several panels.

THUMBNAIL
A rough small-scale sketch used for planning a page layout.

TWO-POINT PERSPECTIVE
A perspective with two vanishing points.

VANISHING POINT
The point where perspective lines meet.

WIRE FRAME
A simple stick-figure showing your hero's pose, which works as a guide for drawing the hero.